Cool Restaurants
New York

3rd edition

teNeues

Imprint

Editors: Désirée von la Valette, Martin Nicholas Kunz

Editorial coordination: Viviana Guastalla, Manuela Roth

Photos (location): courtesy 21 Club (pages 10, 11), Mark Molloy (Club 21 pages 12, 13), Battman NYC (Club 21 page 14), courtesy Aquavit, Laura Resen (Balthazar pages 18, 20), Claudia Hehr (Balthazar page 19, Café Gitane, Centovini pages 40, 41, Doyers, Falai, Florent, Ginger, La Esquina, The Spotted Pig, Una Pizza Napoletana), Eric Laignel (Boqueria, Borough Food & Drink, Buddakan pages 34, 35, Kobe Club), David Leventi (Buddakan pages 32, 33, 36, 37), Michael Harlan Turkell (Centovini pages 42, 43, 44), Carlo van de Roer (Freemans), courtesy Indochine (page 62), Michelle Galindo (Matsuri page 86, Mercer Kitchen page 91, Perry St page 105, Spice Market pages 110, 111), Roberto D'Addona (Lever House, Lure Fishbar), courtesy Mercer Kitchen (page 94), Scott Frances (Nobu Fifty Seven), Jeremy Liebman (Stand), Alan Batt (Telepan), courtesy The Stanton Social, Takahiko Marumoto (wd~50). All other photos by Martin Nicholas Kunz

Introduction: Jake Townsend

Layout: Martin Nicholas Kunz, Viviana Guastalla

Imaging & Pre-press: Jan Hausberg

Translations: Alphagriese Fachübersetzungen, Dusseldorf, Nina Hausberg (English/German, recipes)

Produced by fusion publishing GmbH, Stuttgart . Los Angeles www.fusion-publishing.com

Published by teNeues Publishing Group

teNeues Verlag GmbH + Co. KG	teNeues Publishing Company	teNeues Publishing UK Ltd.
Am Selder 37	16 West 22nd Street	P.O. Box 402
47906 Kempen, Germany	New York, NY 10010, USA	West Byfleet, KT14 7ZF
Tel.: 0049-2152-916-0	Tel.: 001-212-627-9090	Great Britain
Fax: 0049-2152-916-111	Fax: 001-212-627-9511	Tel.: 0044-1932-403509
Press department:		Fax: 0044-1932-403514
arehn@teneues.de		
Tel.: 0049-2152-916-202		

teNeues France S.A.R.L.
93, rue Bannier
45000 Orléans, France
Tel.: 0033-2-38 54 10 71
Fax: 0033-2-38 62 53 40

www.teneues.com

ISBN: 978-3-8327-9232-9

© 2007 teNeues Verlag GmbH + Co. KG, Kempen

Printed in Italy

Bibliographic information published by Die Deutsche Bibliothek.
Die Deutsche Bibliothek lists this publication in the Deutsche Nationalbibliografie;
detailed bibliographic data is available in the Internet at http://dnb.ddb.de.

Average price reflects the average cost for a dinner main course without beverages. Recipes serve four.

Contents

	Page
Introduction	5

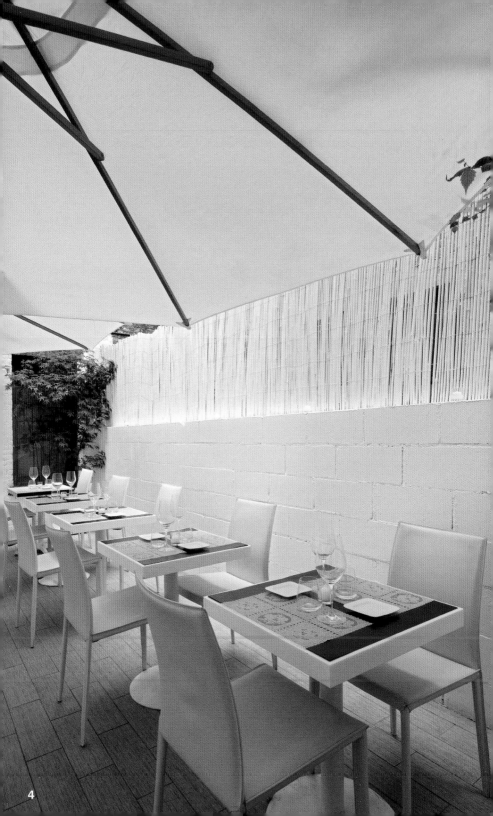

Introduction

New York restaurants elevate the simple act of eating to an elegantly complex art form whose aim is not only to satiate the palate, but to expand the mind. Thus, Manhattan restaurants are not just places to meet friends, or to experience great meals, these are stages upon which the world's great chefs, both well known and yet to be discovered, create food that draws inspiration from every corner of the earth. Besides, great restaurants in New York are no longer only for the very rich, but offer incredible meals for any budget. These thirty extraordinary places are symphonies of sensory stimulation in which design, service, food and ambience work together in concert to provide guests with experiences that continue to delight long after the last dish has been cleared away. Whether it is an evening spent savoring a plate of roast suckling pig cooked over an open flame at *Peasant* or eating in the cool, subdued main room at Jean-Georges Vongerichten's unparalleled *Perry St*, dinner in the City means more than simply a great steak with a nice glass of red wine, it means partaking of the very best food that the world has to offer in the hottest places in town. If it's seafood you crave, then *Lure Fishbar* is your destination for its nautical chic and utterly fresh lobster. For otherworldly Japanese cuisine, those in the know head to *EN Japanese Brasserie* to feast on Uni tofu while sipping on cups of rare sake. Even for those familiar with New York City, this book will serve as an indispensable companion to the best Manhattan dining in the most beautiful or trendy settings, presenting both places for delicious lunch snacks and longsome dinners. And for those who may not have the opportunity to experience New York's coolest restaurants in person, this book has managed to wrest some of the most coveted recipes from the world's greatest chefs so that you can experience the latest creation of cooking's masters in the privacy of your kitchen.

Jake Townsend

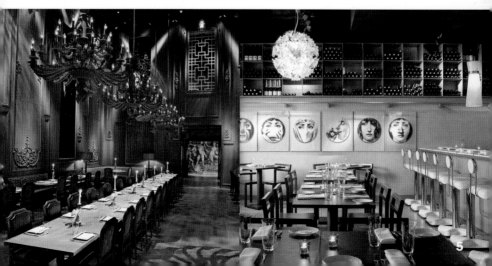

Einleitung

New Yorker Restaurants erheben den simplen Akt des Speisens zu einer eleganten, komplexen Kunstform, deren Ziel es ist, nicht nur den Gaumen zu befriedigen, sondern den geistigen Horizont zu erweitern. Die Restaurants Manhattans sind daher nicht nur Orte, um Freunde zu treffen oder großartige Gerichte auszupropieren, es sind Bühnen, auf denen die besten Küchenchefs der Welt, sowohl berühmte als auch solche, die es zu entdecken lohnt, Speisen kreieren, und sich hierfür Inspiration aus allen Winkeln der Erde holen. Großartige Restaurants in New York sind zudem nicht mehr länger nur den Reichen vorbehalten, sondern bieten unglaublich köstliche Gerichte für jedes Budget an. Diese dreißig außergewöhnlichen Orte sind Symphonien von sensorischen Stimulationen, bei denen Design, Service, Speisen und Ambiente im Konzert zusammenwirken, um den Gästen Erlebnisse zu bieten, an denen sie sich noch lange, nachdem der letzte Teller abgeräumt wurde, erfreuen können. Egal ob man den Abend im *Peasant* beim Genießen eines Tellers gegrilltem, über offenem Feuer geröstetem Spanferkels verbringt, oder ob man in dem kühlen, gedämpften Hauptraum in Jean-Georges Vongerichtens beispiellosem *Perry St* diniert; ein Abendessen in der City ist mehr als nur ein hervorragendes Steak mit einem guten Glas Rotwein. Es bedeutet teilzuhaben am besten Essen, das die Welt an den angesagtesten Orten der Stadt zu bieten hat. Wenn Sie sich nach Meeresfrüchten sehnen, dann ist die *Lure Fishbar* Ihr Ziel wegen ihres nautischen Schicks und des superfrischen Lobsters. Kenner der himmlischen japanischen Küche machen sich auf den Weg zur *EN Japanese Brasserie*, um sich am Uni-Tofu gütlich zu tun, während sie an Tässchen mit einem seltenen Reiswein nippen. Dieses Buch wird zu einem unverzichtbaren Begleiter selbst für diejenigen, die mit New York City vertraut sind. Ein Begleiter, der Sie zu den schönsten und trendigsten Schauplätzen der Stadt führt, wo Sie das beste Essen Manhattans bekommen und nach Herzenslust dinieren können. Das Buch stellt Orte vor, wo man köstliche Mittags-Snacks einnehmen oder ausgedehnte Dinner zelebrieren kann. Und für diejenigen, die nicht die Gelegenheit haben, persönlich die coolsten Restaurants in New York zu erleben, hat es dieses Buch geschafft, den besten Chefköchen der Welt einige der begehrtesten Rezepte abzuringen, sodass Sie die neuesten Kreationen der Meisterköche ungestört in ihrer eigenen Küche ausprobieren können.

Jake Townsend

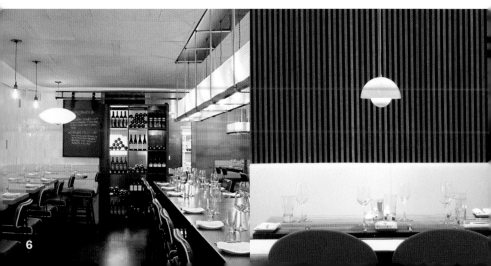

Introduction

Les restaurants de New York élèvent le simple fait de se nourrir au rang d'art complexe et élégant dont le but n'est pas seulement de satisfaire le palais, mais aussi d'ouvrir l'esprit. Ainsi les restaurants de Manhattan ne sont pas que des lieux où rencontrer ses amis, où goûter de fabuleux plats, ce sont des scènes où les plus grands chefs du monde, connus ou encore à découvrir, créent des recettes qui tirent leur inspiration de tous les coins du monde. Les grands restaurants de New York ne sont plus seulement réservés aux très riches, ils offrent des plats incroyables pour tous les budgets. Ces trente lieux extraordinaires proposent des symphonies de stimulation sensorielle dans lesquelles le design, le service, la nourriture et l'ambiance s'allient pour offrir aux clients une expérience qui prolonge le délice longtemps après que le dernier plat a été débarrassé. Que ce soit une soirée passée à savourer un cochon de lait rôti dans la cheminée du *Peasant*, ou un repas dans la grande salle élégante et discrète de l'exceptionnel *Perry St* de Jean-Georges Vongerichten, un dîner dans la City signifie bien plus qu'un bon steak avec un verre de vin rouge, c'est partager ce que le monde a de meilleur à offrir dans les lieux les plus courus de la ville. Si vous avez envie de fruits de mer, *Lure Fishbar* sera votre destination pour son chic nautique et son homard parfaitement frais. Pour une cuisine japonaise extraordinaire, les initiés se dirigent vers l'*EN Japanese Brasserie* pour festoyer d'Uni tofu en sirotant un saké rarissime. Même pour ceux qui connaissent New York, ce livre deviendra un compagnon indispensable pour les meilleurs repas à Manhattan dans les cadres les plus beaux ou les plus tendance, en présentant le lieu idéal pour de délicieux déjeuners sur le pouce ou des dîners qui s'éternisent. Et pour ceux qui n'auraient pas la chance de tester en personne les meilleurs restaurants de New York, ce livre a réussi à arracher aux meilleurs chefs du monde quelques unes de leurs recettes les plus convoitées, pour que vous puissiez goûter les dernières créations des maîtres de la cuisine dans l'intimité de votre foyer.

Jake Townsend

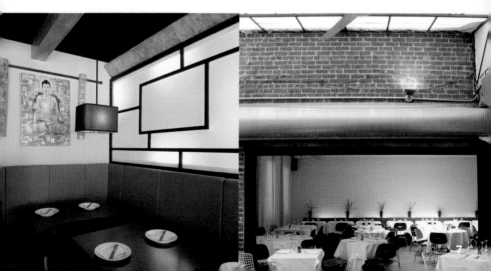

Introducción

Los restaurantes de Nueva York elevan el simple acto de comer a una forma artística elegantemente compleja, cuyo objetivo no se limita a saciar el paladar, sino que expande la mente. Los restaurantes de Manhattan no son simplemente sitios para encontrar a los amigos o para experimentar óptimas comidas, más bien son escenarios sobre los que actúan los más grandes cocineros del mundo, famosos o todavía por descubrir, creando platos que toman inspiración desde cada rincón de la tierra. Los grandes restaurantes de Nueva York ya no son destinados sólo a los más adinerados, sino que ofrecen comidas increíbles para cada presupuesto. Estos treinta extraordinarios sitios representan sinfonías de estimulación sensorial en las que diseño, servicio, comida y ambiente colaboran en concierto para regalar a los huéspedes experiencias que seguirán deleitándoles durante mucho tiempo después que el último plato haya sido retirado. Tanto en una tarde saboreando cochinillo asado a fuego directo en el *Peasant*, como en una comida en el salón principal, sereno y relajado, del incomparable *Perry St* de Jean-Georges Vongerichten, comer en la City significa algo más que un excelente bistec con un buen vaso de vino tinto, significa participar en la mejor comida en absoluto que el mundo pueda ofrecer, en los lugares más en boga de la ciudad. Para quienes tengan ganas de mariscos, el *Lure Fishbar* es el destino ideal, por su estilo náutico chic y sus fresquísimas langostas. Para comida japonés del otro mundo, los que saben se dirigen hacia la *EN Japanese Brasserie* para banquetear con tofu uni, sorbiendo copitas de raro sake. Incluso para quienes tengan familiaridad con la ciudad de Nueva York, este libro servirá de compañero imprescindible para la mejor comida de Manhattan en los sitios más hermosos y de tendencia, presentando locales adaptos tanto para deliciosos almuerzos como para cenas prolongadas. Y también para los que quizás no tengan la oportunidad de experimentar en persona los restaurantes más cool de Nueva York, este libro ha conseguido arrebatar a los cocineros más grandes del mundo algunas de sus recetas más codiciadas, así que el lector podrá experimentar las últimas creaciones de los maestros de la cocina en la intimidad se su casa.

Jake Townsend

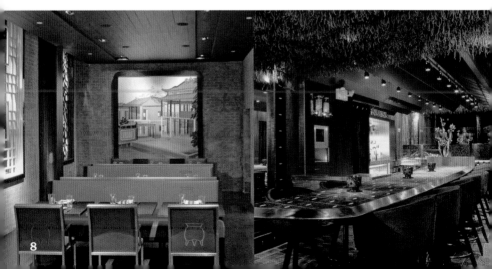

Introduzione

I ristoranti di New York elevano il semplice atto di mangiare ad una forma d'arte elegantemente complessa, il cui scopo non è solo saziare il palato, ma espandere la mente. I ristoranti di Manhattan non sono solamente posti dove incontrare gli amici o dove sperimentare ottimi pasti, sono palcoscenici sui quali i più grandi chef del mondo, alcuni ben noti e altri ancora da scoprire, creano cibi che traggono ispirazione da ogni angolo della terra. I grandi ristoranti di New York non sono più riservati ai più abbienti, ma offrono pasti incredibili per tutte le tasche. Questi trenta straordinari luoghi sono sinfonie di stimoli sensoriali, nelle quali il design, il servizio, il cibo e l'ambientazione collaborano in concerto per regalare agli ospiti esperienze che continuano a deliziare a lungo, anche dopo che l'ultimo piatto è stato ritirato. Che si tratti di una serata passata ad assaporare un piatto di porchetta arrostita su fiamma libera al *Peasant*, o di un pranzo nel salone dell'ineguagliabile *Perry St* di Jean-Georges Vongerichten, con la sua tenue atmosfera *cool*, mangiare fuori nella City significa molto di più che semplicemente un'ottima bistecca con un buon bicchiere di vino rosso: significa condividere il miglior cibo in assoluto che il mondo può offrire, nei locali più *hot* della città. Per chi desideri dei frutti di mare, il *Lure Fishbar* è la destinazione consigliata, per il suo stile nautico chic e le aragoste freschissime. Per provare cucina giapponese dell'altro mondo, i conoscitori scelgono la *EN Japanese Brasserie* per banchettare con del tofu uni sorseggiando coppe di sakè raro. Anche per coloro che hanno familiarità con New York, questo libro servirà da compagno inseparabile per i pasti negli ambienti più belli e più di tendenza, presentando locali sia per deliziosi pranzi rapidi che per cene prolungate. E per coloro che magari non hanno l'opportunità di sperimentare di persona i ristoranti più *cool* di New York, quest'opera è riuscita a strappare dalle mani dei più grandi chef del mondo alcune delle ricette più ambite, cosicché potrete sperimentare le ultime creazioni dei maestri della cucina nella privacy di casa vostra.

Jake Townsend

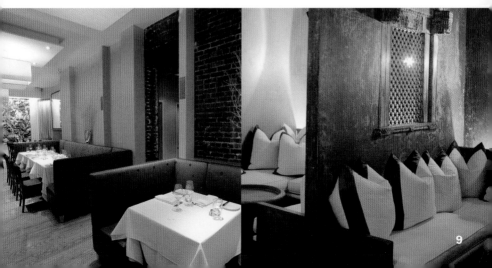

21 Club

Chef: John Greeley | Owner: Orient-Express Hotels, Trains & Cruises

21 West 52nd Street | New York, NY 10019 | Midtown
Phone: +1 212 582 7200
www.21club.com
Subway: E, V 53 Street – Fifth Avenue; B, D, F, V Rockefeller Center
Opening hours: The Upstairs at '21' Tue–Sat 5:30 pm to 10 pm, The Bar Room Mon–Thu
noon to 2:30 pm, 5:30 pm to 10 pm, Fri noon to 2:30 pm, Sat 5:30 pm to 11 pm
Average price: $ 75 The Upstairs at '21', $ 75 The Bar Room
Cuisine: Traditional and New American
Special features: 10 private dining rooms, legendary Prohibition-era wine cellar

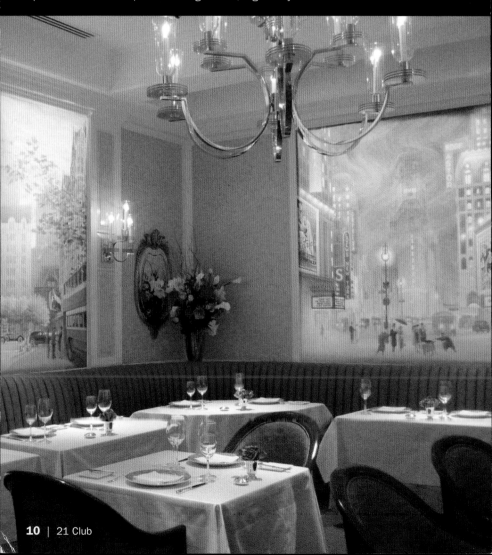

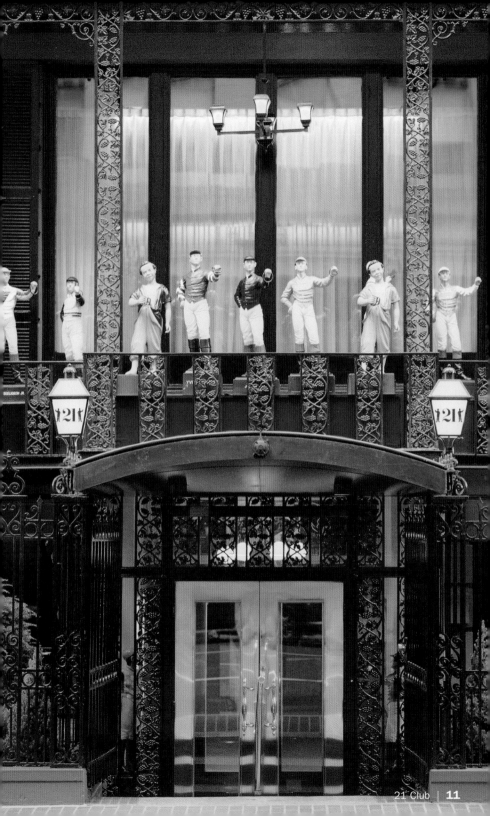

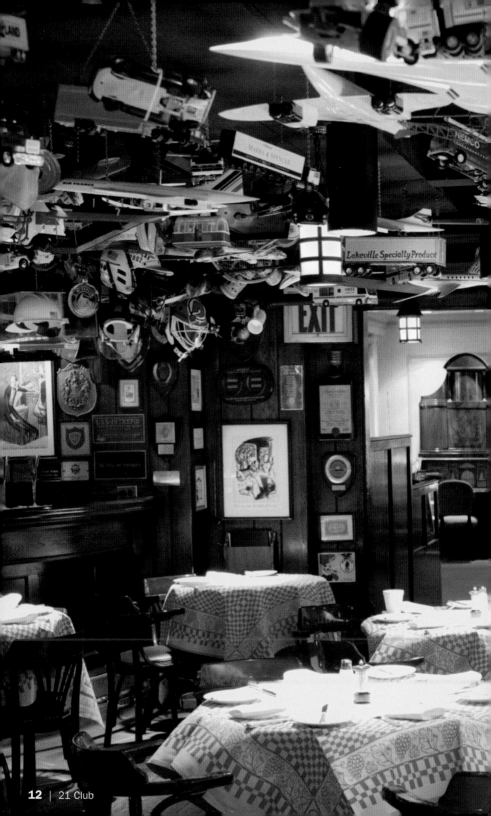

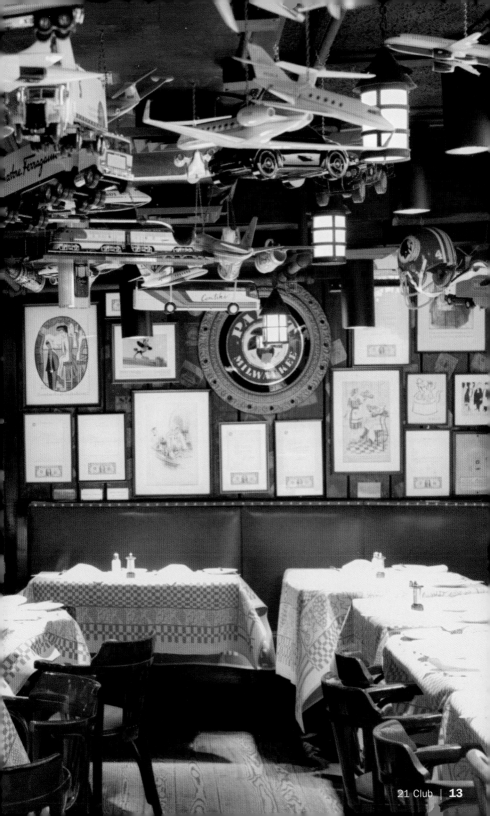

Rack of Venison
with Chili and Blackberry Sauce

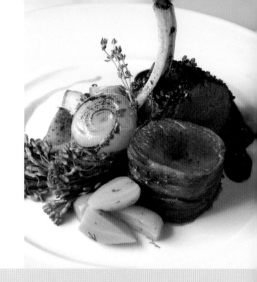

Rehrücken
mit Chili an Brombeersauce

Carré de chevreuil
sauce au chili et aux mûres

Lomo de ciervo
con chili y salsa de moras

Lombata di capriolo
con chili e salsa di more

2 racks of venison (one boned, one with rib bones)
2 tbsp ground coffee
2 tbsp cocoa powder
1 tbsp ground black pepper
1 tbsp paprika
1 tbsp ground coriander
1 tbsp chili powder

Combine all seasonings and massage into the meat. Let rest for 5 minutes, then sear from all sides and braise in an oven at 350°F for approx. 7–10 minutes. Before carving, let the meat rest on a warm place for 10 minutes. Cut both racks into 4 pieces and place one piece with and one without bones on 4 plates.

125 ml reduced veal fond
2 tbsp honey
2 tbsp dark balsamic vinegar
7 oz blackberries
Fresh, halved blackberries for decoration
Salt, pepper

Combine veal fond, honey, vinegar and blackberries in a small pot, let simmer for 5 minutes, blend and pour through a strainer. Season with salt and pepper. Serve with steamed carrots and savoy cabbage and garnish with halved blackberries.

2 Rehrücken (einer ausgelöst, einer mit Rippenknochen)
2 EL Kaffeepulver
2 EL Kakaopulver
1 EL gemahlener schwarzer Pfeffer
1 EL Paprikapulver
1 EL gemahlener Koriander
1 EL Chilipulver

Alle Gewürze mischen und in das Fleisch einmassieren. 5 Minuten ruhen lassen, danach das Fleisch von allen Seiten anbraten und bei 180°C ca. 7–10 Minuten im Ofen garen. Vor dem Aufschneiden 10 Minuten an einem warmen Ort ruhen lassen. Beide Rücken in 4 Teile schneiden und jeweils ein Stück mit und ohne Knochen auf 4 Tellern verteilen.

125 ml reduzierter Kalbsfond
2 EL Honig
2 EL dunkler Balsamico-Essig
200 g Brombeeren
Salz, Pfeffer
Frische, halbierte Brombeeren zur Dekoration

Kalbsfond, Honig, Essig und Brombeeren in einen kleinen Topf geben, 5 Minuten köcheln lassen, pürieren und durch ein Sieb gießen. Mit Salz und Pfeffer abschmecken. Mit gedünsteten Karotten und Wirsinggemüse servieren und mit den halbierten Brombeeren garnieren.

2 carrés de chevreuil (un désossé, l'autre avec les os)
2 c. à soupe de café moulu
2 c. à soupe de cacao en poudre
1 c. à soupe de poivre noir moulu
1 c. à soupe de paprika
1 c. à soupe de coriandre moulue
1 c. à soupe de chili en poudre

Mélanger tout l'assaisonnement et malaxer la viande avec la préparation. Laisser reposer 5 minutes, puis saisir sur toutes les faces et faire cuire au four à 180°C pendant environ 7 à 10 minutes. Avant de la découper, laisser reposer la viande dans un endroit chaud pendant 10 minutes. Couper les deux carrés en 4 et placer un morceau avec os et un morceau désossé sur chacune des 4 assiettes.

125 ml de fond de veau réduit
2 c. à soupe de miel
2 c. à soupe de vinaigre balsamique
200 g de mûres
Quelques mûres fraîches coupées en deux pour la présentation
Sel, poivre

Mélanger le fond de veau, le miel, le vinaigre et les mûres dans une petite casserole, faire mijoter à petits bouillons pendant 5 minutes, mixer et passer au chinois. Saler, poivrer. Servir avec des carottes et du chou de milan cuits à la vapeur, et garnir de moitiés de mûres.

2 lomos de ciervo (uno deshuesado y uno con costillas)
2 cucharadas de café molido
2 cucharadas de cacao en polvo
1 cucharada de pimienta negra molida
1 cucharada de páprika
1 cucharada de cilantro molido
1 cucharada de chili en polvo

Combinar todos los condimentos y masajearlos en la carne. Dejar reposar durante 5 minutos, luego abrasar por todos los lados y dorar en el horno a 180° durante 7–10 minutos. Antes de cortar, dejar reposar la carne en un lugar cálido durante 10 minutos. Cortar ambos lomos en 4 porciones y colocar una porción con hueso y una sin hueso en cada plato.

125 de caldo magro de ternera
2 cucharadas de miel
2 cucharadas de vinagre balsámico oscuro
200 g de moras
Moras frescas cortadas por la mitad, para decoración
Sal y pimienta

Combinar el caldo de ternera, la miel, el aceite y las moras en una cazuela, dejar cocer a fuego lento durante 5 minutos, mezclar y pasar por un colador. Aderezar con sal y pimienta. Servir con zanahorias al vapor y coles de Milán. Adornar con las moras partidas por la mitad.

2 lombate di capriolo (una disossata, una con le costole)
2 cucchiai di caffè macinato
2 cucchiai di polvere di cacao
1 cucchiaio di pepe nero macinato
1 cucchiaio di paprika
1 cucchiaio di coriandolo macinato
1 cucchiaio di peperoncino in polvere

Combinare i condimenti e massaggiarli nella carne. Lasciare riposare per 5 minuti, poi scottare su tutti i lati e brasare in forno a 180°C per circa 7–10 minuti. Prima di tagliare, lasciare riposare la carne in un luogo caldo per 10 minuti. Tagliare entrambe le lombate in 4 porzioni e collocare una porzione con l'osso e una senza osso su 4 piatti.

125 ml di brodo magro di vitello
2 cucchiai di miele
2 cucchiai di aceto balsamico scuro
200 g di more
Sale e pepe
More fresche tagliate a metà, per la decorazione

Combinare il brodo di vitello, il miele, l'aceto e le more in un tegamino, lasciare bollire a fuoco lento per 5 minuti, mescolare e passare con un colino. Condire con sale e pepe. Servire con carote al vapore e cavolo cappuccio e guarnire con le mezze more.

Aquavit

Design: Owen & Mandolfo of New York & Arkitema of Copenhagen
Chef: Johan Svensson | Owners: Håkan Swahn, Marcus Samuelsson

65 East 55th Street | New York, NY 10017 | Midtown
Phone: +1 212 307 7311
www.aquavit.org
Subway: 6 51 Street; E, V 53 Street
Opening hours: Mon–Fri, Sun noon to 2:30 pm, 5:30 pm to 10:30 pm, Sat open till 10:45 pm
Average price: Café: lunch Prix Fixe $ 24, dinner $ 17, Dining Room: lunch Prix Fixe $ 39,
dinner Prix Fixe $ 82, tasting menu $ 120
Cuisine: Scandinavian
Special features: Traditional Swedish Smørgasbord on Sundays from noon to 2:30 pm

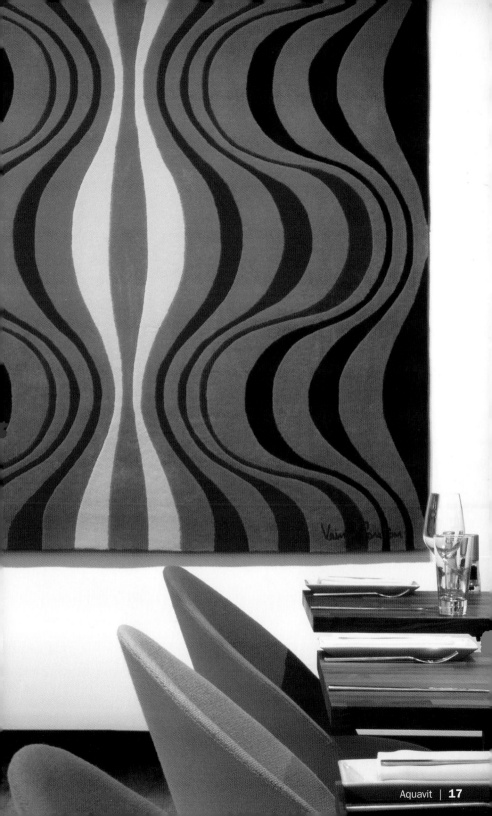

Balthazar

Chef: Riad Nasr, Lee Hanson | Owner: Keith McNally

80 Spring Street | New York, NY 10012 | SoHo
Phone: +1 212 965 1414
www.balthazarny.com
Subway: N, R, W Prince Street; 6 Spring Street
Opening hours: Mon–Thu 7:30 am to 11:30 am, noon to 5 pm, 5:45 pm to 12:30 am,
Fri to 2:30 am, Sat–Sun continental breakfast 8 am to 10 am, brunch 10 am to
4 pm, lunch noon to 5 pm, dinner 5:45 pm to 2:30 am, Sun to 12:30 am
Average price: $ 20
Cuisine: Traditional French

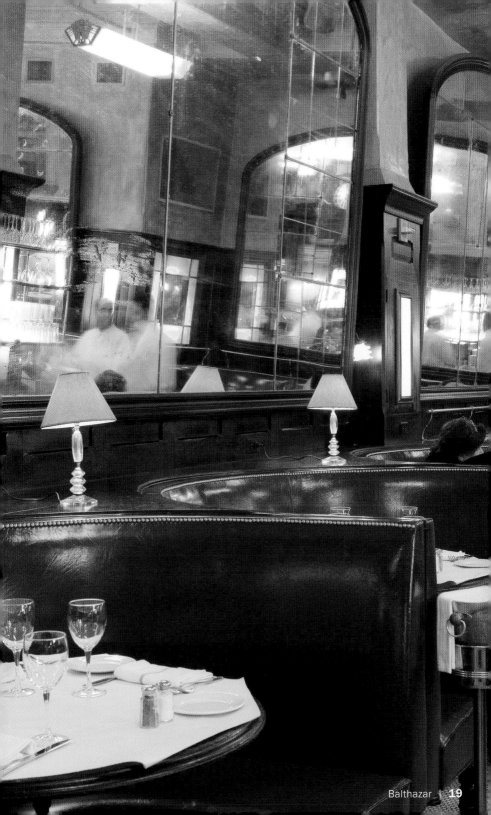

Frisée

aux Lardons

Frisée mit Speckwürfeln
Frisée aux lardons
Frisée con dados de tocino
Frisé con speck a dadini

8 slices white bread from the previous day
4 heads frisée lettuce
7 oz diced bacon
2 shallots, diced
60 ml Sherry vinegar
3 tbsp olive oil
Salt, ground pepper
4 large eggs
100 ml vinegar
2 tbsp salt
3 tbsp herb mixture (parsley, chives, chervil, etc.)

Remove the bread crust and cut the bread in cubes. Put on a baking sheet and roast in a 390°F oven for approx. 10 minutes, until golden brown. Use only the inner part of the frisée lettuce, clean, dry and pull into small pieces. In a hot pan fry the bacon without fat, add the shallots and fry until golden brown. Add vinegar and reduce to one half. Take off the stove and season with olive oil, salt and pepper. Bring plenty of water in a separate pot to a boil, add vinegar and salt and carefully poach the eggs for 4 minutes. Mix the croutons with the frisée lettuce, toss with the dressing and divide onto 4 plates. Place the eggs on top of the salad, season with salt and pepper and sprinkle with the herbs.

8 Scheiben Weißbrot vom Vortag
4 Köpfe Frisée-Salat
200 g Speckwürfel
2 Schalotten, gewürfelt
60 ml Sherry-Essig
3 EL Olivenöl
Salz, gemahlener Pfeffer
4 große Eier
100 ml Essig
2 EL Salz
3 EL Kräutermischung (Petersilie, Schnittlauch, Kerbel, etc.)

Die Rinde vom Weißbrot entfernen und das Brot in Würfel schneiden. Auf ein Backblech legen und bei 200 °C ca. 10 Minuten goldbraun rösten. Nur das Innere der Frisée-Salate verwenden, waschen, trocken schleudern und in kleine Stücke zupfen. In einer heißen Pfanne den Speck ohne Fett anbraten, die Schalotten zugeben und goldbraun braten. Mit 60 ml Sherry-Essig ablöschen und auf die Hälfte einreduzieren lassen. Vom Herd nehmen und mit Olivenöl, Salz und Pfeffer abschmecken. In einem separaten Topf reichlich Wasser erhitzen, 100 ml Essig und 2 EL Salz hinzugeben und die Eier vorsichtig 4 Minuten pochieren. Die Croutons mit dem Frisée-Salat mischen, das Dressing darüber geben und auf 4 Teller verteilen. Die Eier auf den Salat setzen, mit Salz und Pfeffer würzen und mit den Kräutern bestreuen.

8 tranches de pain blanc de la veille
4 salades frisées
200 g de lardons
2 échalotes en dés
60 ml de vinaigre de Sherry
3 c. à soupe d'huile d'olive
Sel, poivre moulu
4 œufs gros
100 ml de vinaigre
2 c. à soupe de sel
3 c. à soupe de mélange d'herbes (persil,
ciboulette, cerfeuil, etc.)

Retirer la croûte du pain blanc et couper ce dernier en cubes. Griller les cubes, jaune brun, sur une plaque de four à 200 °C pendant environ 10 minutes. Utiliser uniquement l'intérieur de la frisée, la nettoyer, l'essorer et la briser en petites branches. Faire revenir les lardons dans une poêle chaude sans graisse, ajouter les échalotes et les cuire jaune brun. Déglacer au vinaigre et laisser réduire ce dernier de moitié. Retirer du feu et assaisonner à l'huile d'olive, saler et poivrer. Dans un pot séparé porter une quantité d'eau suffisante à ébullition, ajouter 100 ml de vinaigre et 2 c. à soupe de sel et pocher les œufs prudemment pendant 4 minutes. Mélanger les croûtons à la frisée, verser la sauce par dessus et répartir sur 4 assiettes. Déposer les œufs sur la salade, poivrer et saler et saupoudrer les herbes.

8 rebanadas de pan blanco del día anterior
4 cabezas de ensalada frisée
200 g dados de tocino
2 chalotes cortados en dados
60 ml vinagre de sherry
3 cucharadas de aceite de oliva
Sal, pimienta molida
4 huevos grandes
100 ml vinagre
2 cucharadas de sal
3 cucharadas de mezcla de hierbas (perejil,
puerro cortado, perifollo, etc.)

Sacar la corteza del pan blanco y cortar el pan en daditos. Colocar sobre una plancha de hornear y tostar a 200 °C por aprox. 10 minutos hasta que los daditos se vuelvan dorado oscuro. Solo usar el interior de las ensaladas frisée, lavar, secar centrifugando y arrancar en pequeños trozos. Colocar el tocino en una sartén caliente y freír el tocino sin grasa, agregar los chalotes y asar hasta que se pongan de un color dorado oscuro. Rebajar con vinagre y dejar que se reduzca a la mitad. Sacar del fuego y sazonar con aceite de oliva, sal y pimienta. Calentar suficiente agua en una olla separada, agregar 100 ml de vinagre y 2 cucharadas de sal y escalfar los huevos con cuidado por 4 minutos. Mezclar los dados de pan tostado con la ensalada frisée, derramar encima el condimento y distribuir en 4 platos. Colocar los huevos sobre la ensalada, sazonar con sal y pimienta y espolvorear con las hierbas.

8 fette di pane bianco raffermo
4 teste d'insalata frisé
200 g di speck a dadini
2 scalogni tagliati a cubetti
60 ml di aceto di Sherry
3 cucchiai di olio d'oliva
Sale, pepe macinato
4 uova grandi
100 ml di aceto
2 cucchiai di sale
3 cucchiai di erbe aromatiche miste (prezzemolo, erba cipollina, cerfoglio, etc.)

Togliere la crosta dal pane e tagliarlo a dadini. Metterlo in una teglia e farlo tostare in forno a 200 °C per circa 10 minuti. Utilizzare solo la parte interna delle insalate frisé, lavarla, asciugarla con una centrifuga e staccarla in piccoli pezzi. Far rosolare lo speck privo di grasso in una padella calda, aggiungere gli scalogni e far dorare il tutto. Smorzare con dell'aceto e far ridurre della metà. Togliere dal fuoco e condire con olio d'oliva, sale e pepe. Far riscaldare abbondante acqua in una pentola a parte, aggiungere 100 ml di aceto e 2 cucchiai di sale e affogare delicatamente le uova per 4 minuti. Aggiungere i croutons all'insalata frisé, mettervi sopra il dressing e distribuirla su 4 piatti. Mettere le uova sull'insalata, condire con sale e pepe e cospargere di erbe aromatiche.

Boqueria

Design: Meyer-Davis Studio | Chef: Seamus Mullen
Owner: Yann de Rochefort

53 West 19th Street | New York, NY 10011 | Flatiron District
Phone: +1 212 255 4160
www.boquerianyc.com
Subway: F, V, B, D 14 Street
Opening hours: Sun–Thu 11 am to midnight, Fri–Sat 11 am to 2 am
Average price: Tapas $ 6, Raciòn $ 20
Cuisine: Regional Spanish, with an emphasis on Catalonian cuisine
Special features: Chef's and communal tables

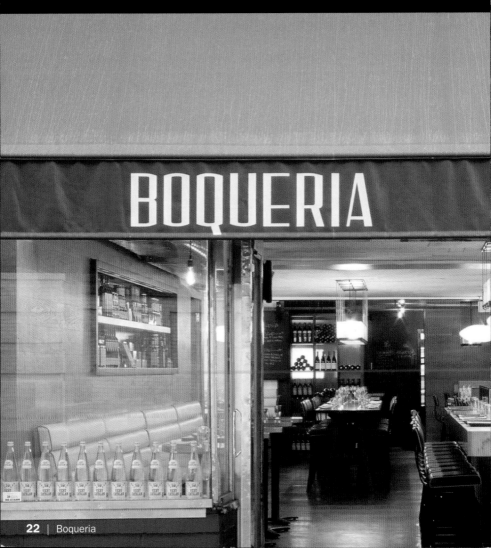

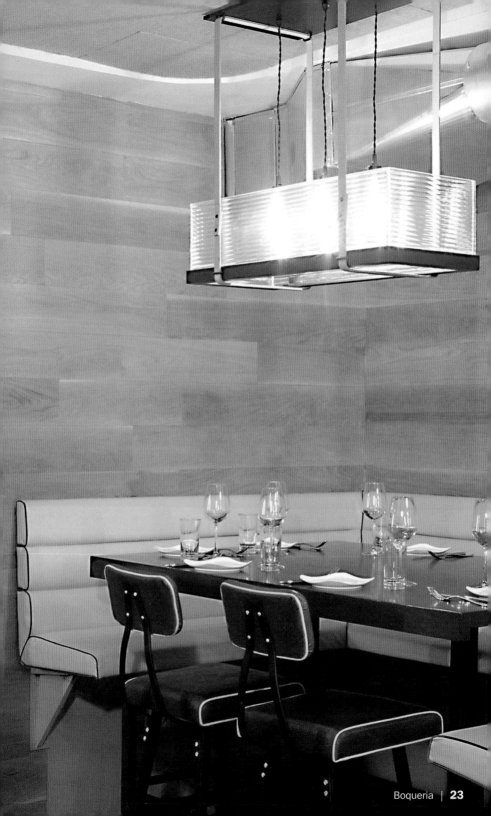

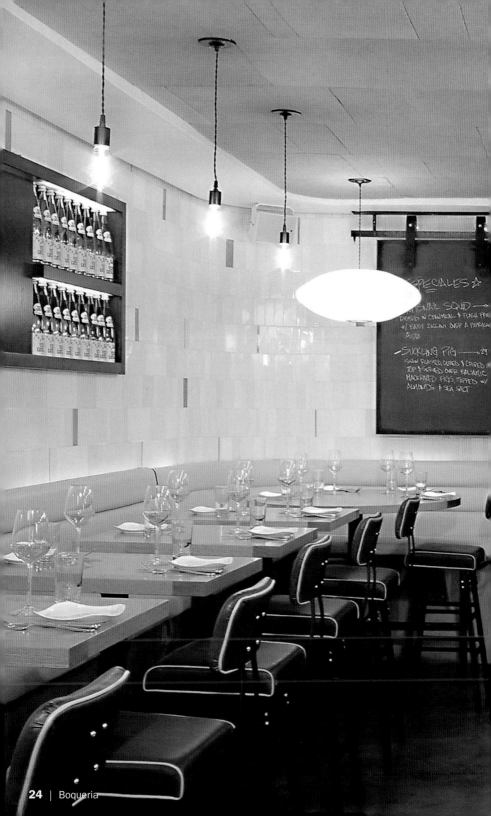

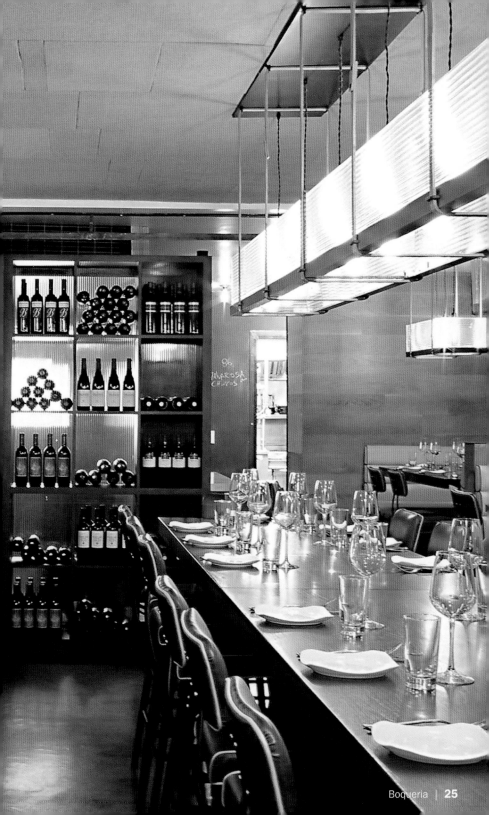

Borough Food & Drink

Design: Mark Zeff | Consulting Chef: Zak Pelaccio | Executive Chef: Paul Williams | Owner: Jeffrey Chodorow, China Grill Management

12 East 22nd Street | New York, NY 10014 | Flatiron District
Phone: +1 212 260 0103
www.chinagrillmgt.com
Subway: N, R, W 23 Street
Opening hours: Mon–Wed 5 pm to 11 pm, Thu–Sat 5 pm to midnight,
Sun 11 am to 4 pm (brunch), 5 pm to 10 pm
Average price: $ 35
Cuisine: Artisanal marketplace

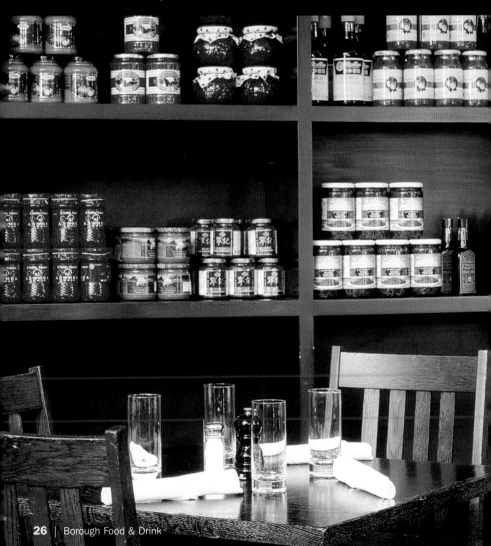

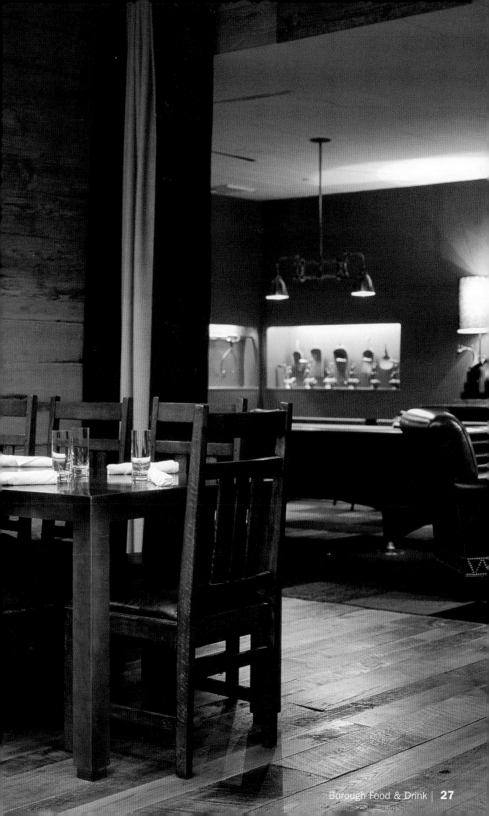

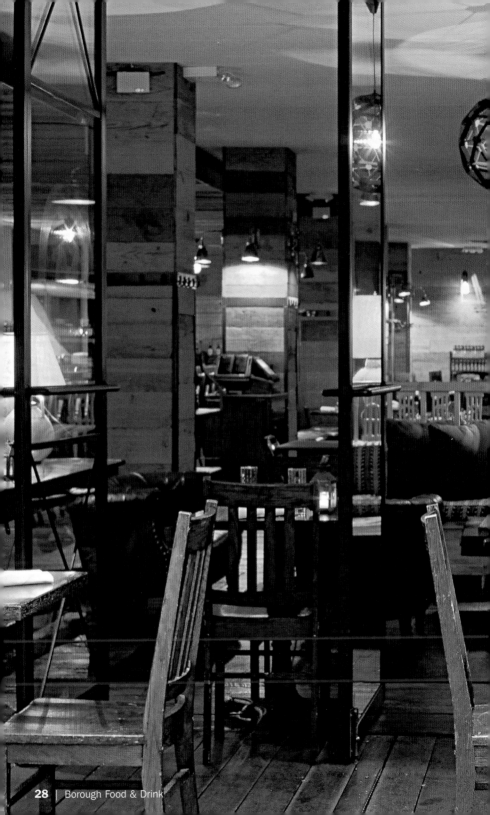

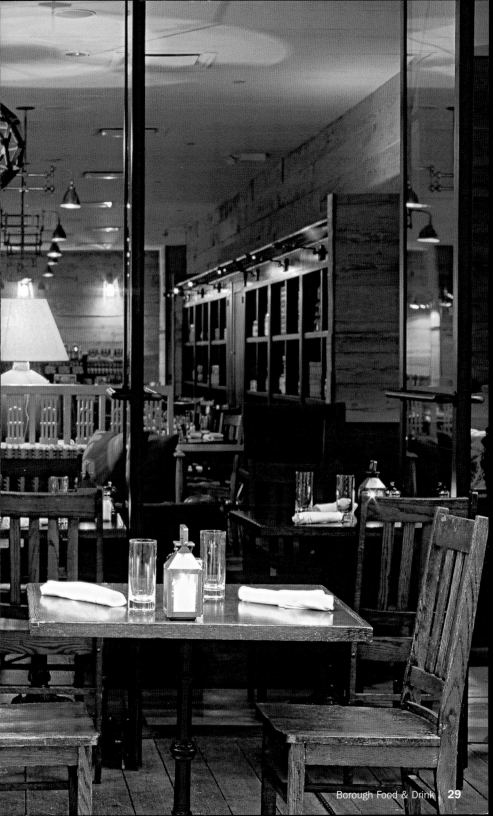

Bottino

Design: Thomas Leeser | Chef, Owner: Daniel Emerman
Co-Owner: Alessandro Prosperi

246 Tenth Avenue | New York, NY 10001 | Chelsea
Phone: +1 212 206 6766
www.bottinonyc.com
Subway: C, E 23 Street
Opening hours: Tue–Sat noon to 11:30 pm, Sun–Mon 6 pm to 10:30 pm
Average price: $ 17
Cuisine: Italian
Special features: Private areas arranged for groups of 25 to 48 guests

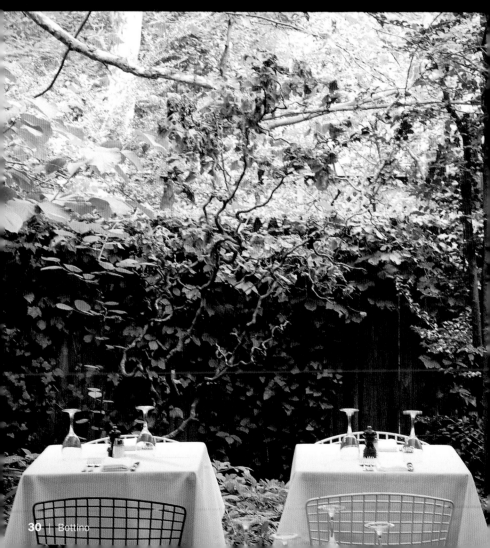

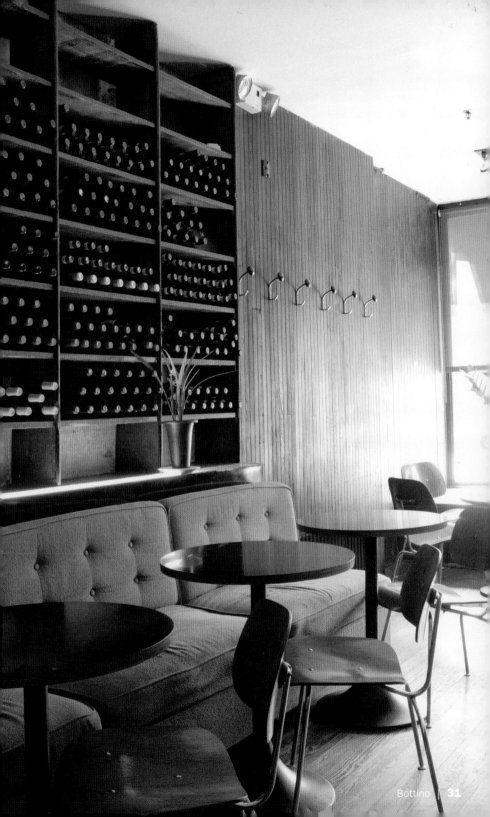

Buddakan

Design: Christian Liaigre | Chef: Lon Symensma
Owner: Stephen Starr

75 Ninth Avenue | New York, NY 10011 | Meatpacking District
Phone: +1 212 989 6699
www.buddakannyc.com
Subway: A, C, E Eighth Avenue; L 14 Street – Eighth Avenue
Opening hours: Sun–Wed 5:30 pm to midnight, Thu–Sat 5:30 pm to 1 am
Average price: $ 26
Cuisine: Modern Chinese
Special features: 24-seat communal dining table

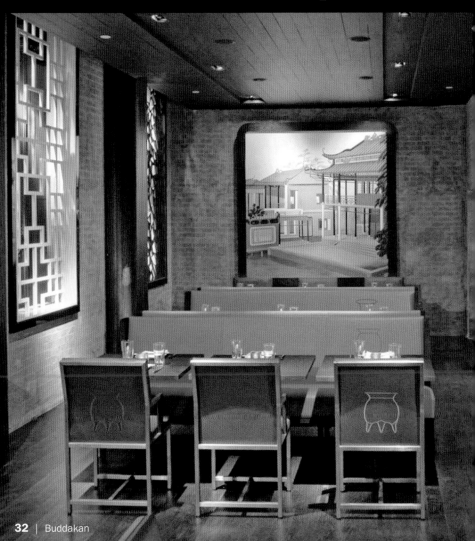

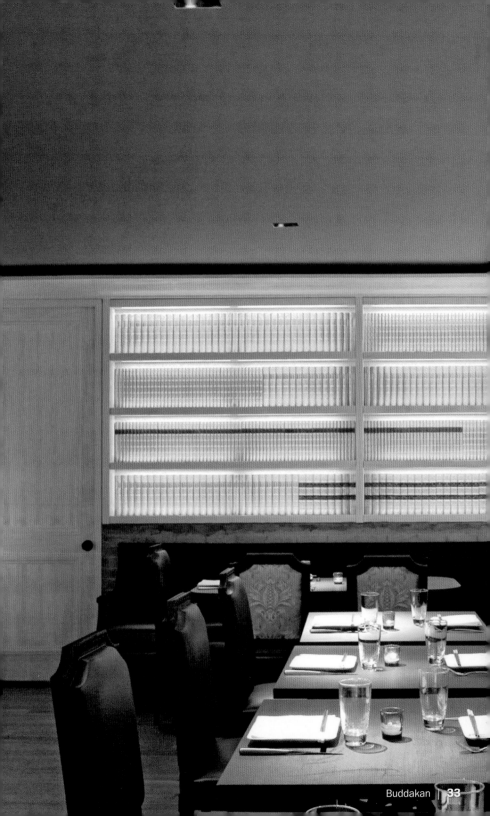

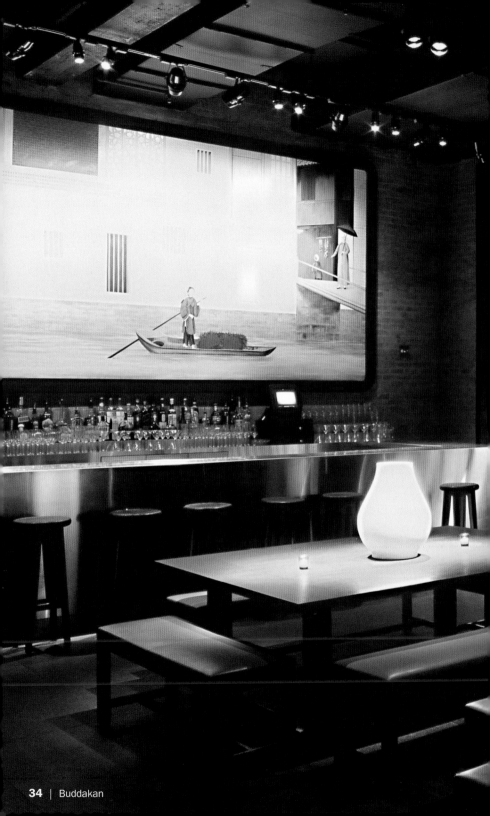

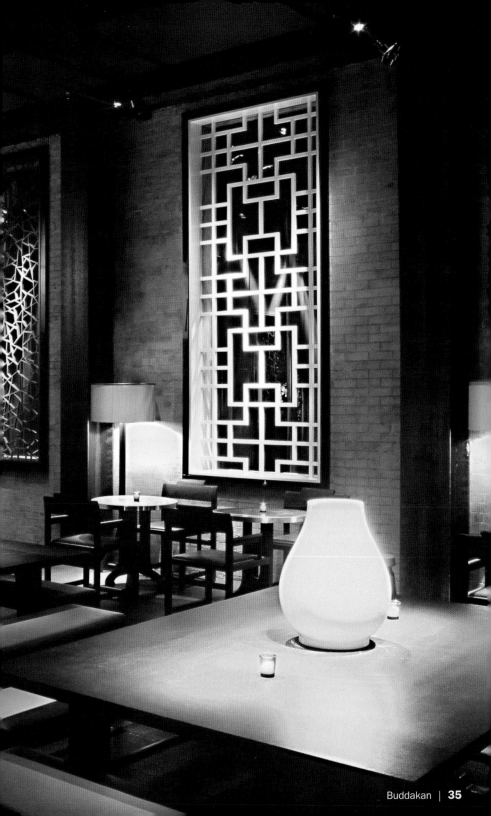

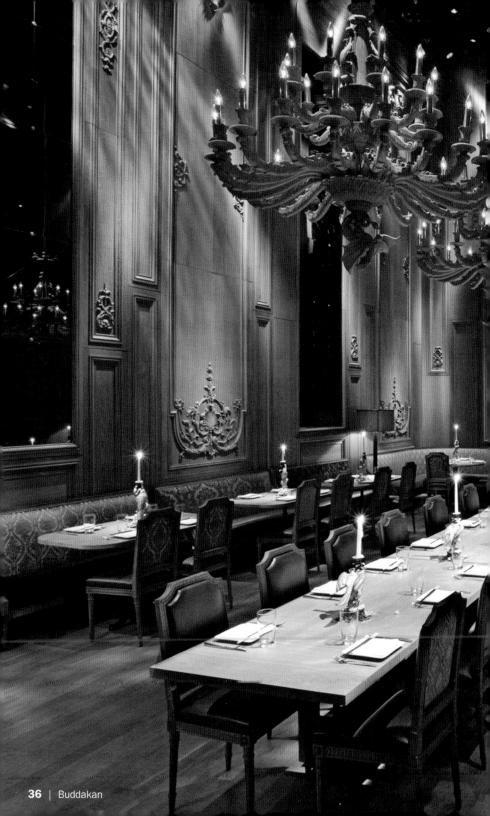

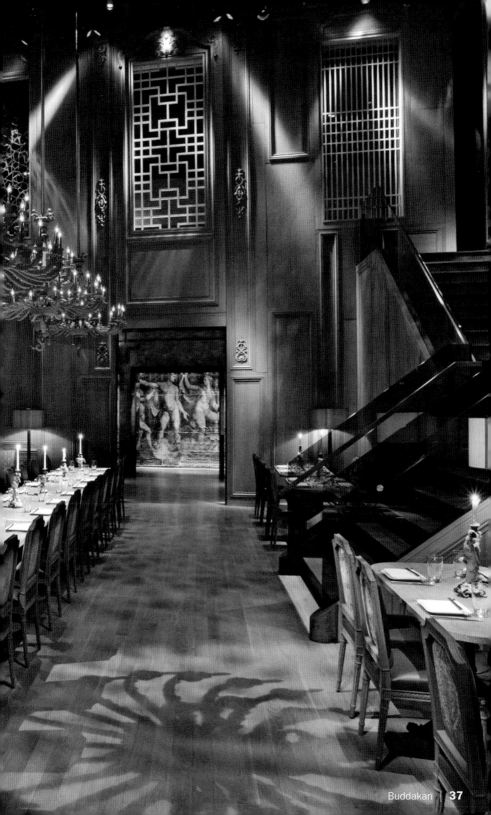

Café Gitane

Design: Luc Levy

242 Mott Street | New York, NY 10012 | NoLlta
Phone: +1 212 334 9552
Subway: F, 6 Broadway – Lafayette Street; N, R Prince Street
Opening hours: Mon–Thu 9 am to midnight, Fri–Sat 9 am to 12:30 am,
Sun 9 am to midnight
Average price: $ 25
Cuisine: French with Moroccan and Australian influences

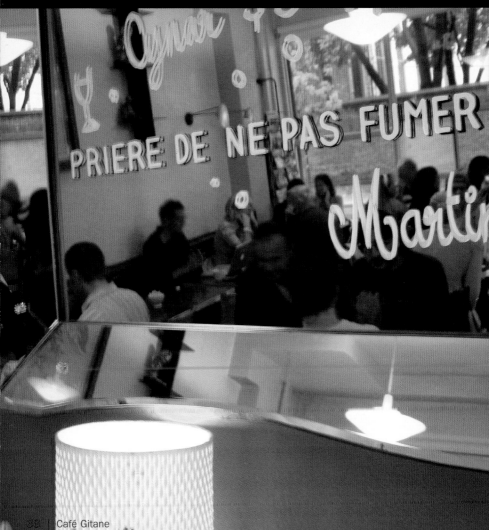

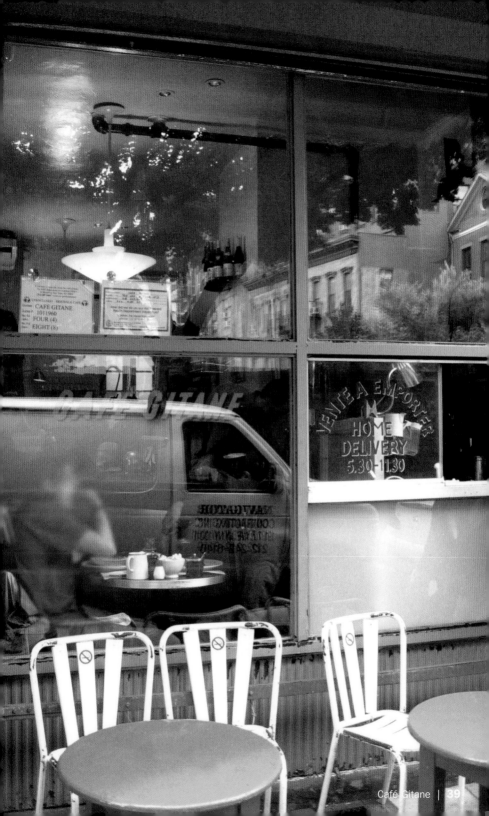

Centovini

Design: Murray Moss | Chef: Patti Jackson
Owners: Murray Moss, Franklin Getchell, Nicola Marzovilla

25 West Houston Street | New York, NY 10012 | SoHo
Phone: +1 212 219 2113
www.centovininyc.com
Subway: 6 Bleecker Street; F, V, B, D Broadway – Lafayette Street; N, R, W Prince Street
Opening hours: Mon–Fri noon to 3 pm, 5:30 pm to 11 pm, Sat noon to 4 pm (brunch),
5:30 pm to 11 pm, Sun noon to 4 pm (brunch), 5:30 pm to 10 pm
Average price: $ 75
Cuisine: Italian
Special features: Wine list, green market cuisine

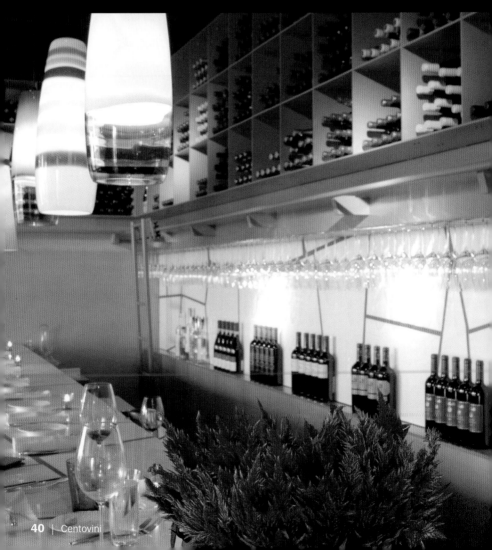

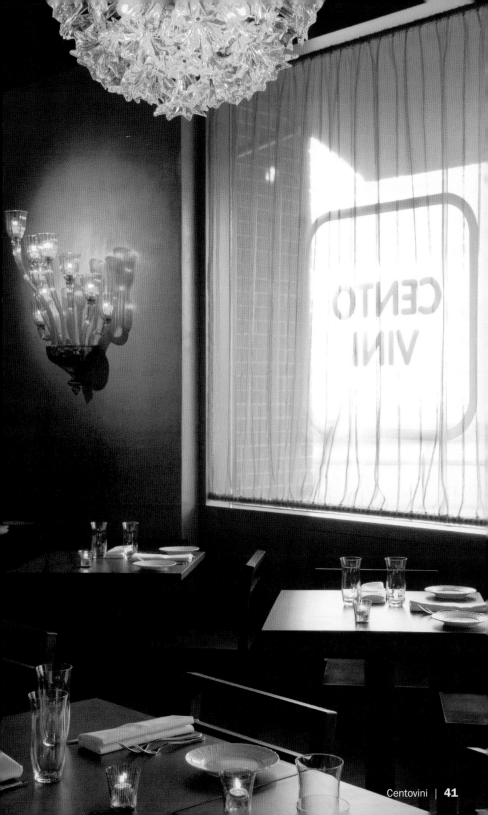

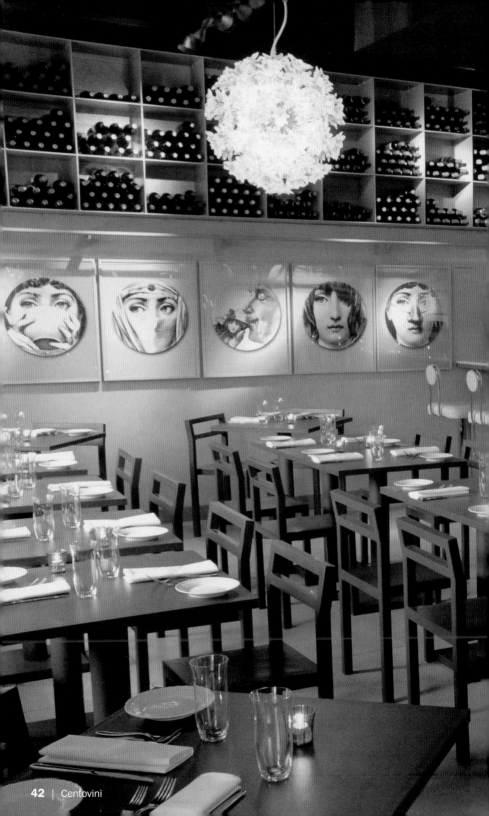

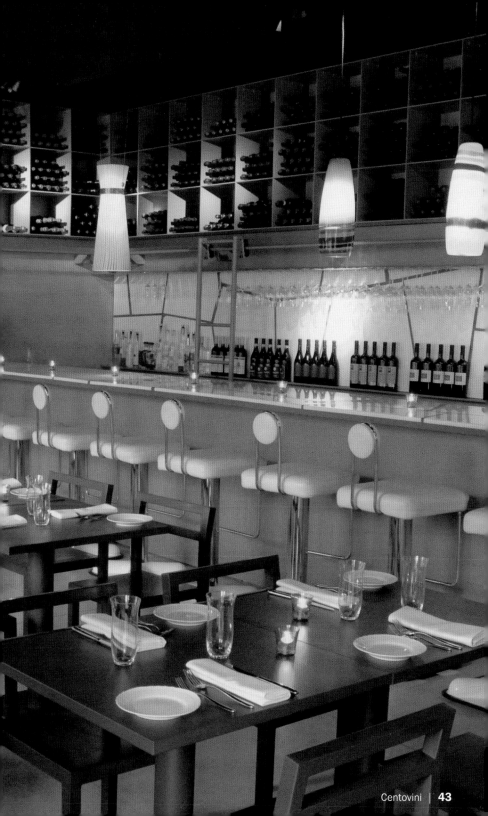

Ricotta-Crème

with Candied Oranges and Cranberry-Confit

Ricotta-Creme mit kandierten Orangen und Cranberry-Confit

Crèmes à la ricotta avec des oranges confites et cranberries au sirop

Flan de ricotta con naranjas confitadas y confitura de arándanos rojos

Budino alla ricotta con arance candite e confettura di ribes

2 oranges, peel only, cut into ¼" strips
16 oz sugar

Blanch the orange strips two or three times in boiling water. Combine 13 oz sugar and 250 ml water and reduce to a thick syrup. Add the orange strips, cook for 5 minutes in the syrup, drain and place the strips on a rack to dry. After cooling off toss the tacky strips in 3 oz sugar and allow to dry.

10 oz fresh cranberries
8 oz sugar
1 cardamom pod

Combine sugar and cardamom pod with 250 ml water and reduce to a thin syrup. Add the cranberries, bring to a boil and chill.

8 oz ricotta, 3 oz mascarpone cheese
½ tsp grated orange peel
½ tsp vanilla extract
2 eggs
3 oz sugar
4 oz cream

Preheat oven to 300°F. Combine all ingredients, until the sugar has dissolved and it resembles a smooth mixture. Pour the mixture into 4 greased ovenproof molds and place in a deep baking dish. Fill boiling water into the baking dish and bake the crèmes for approx. 40–45 minutes. Cool completely and loosen the edges of the crèmes with a sharp knife. Drop onto the plates and garnish with cranberries and orange strips.

Schale von 2 Orangen, in 5 mm breiten Streifen
500 g Zucker

Die Orangenstreifen zwei- bis dreimal in kochendem Wasser blanchieren. 400 g Zucker mit 250 ml Wasser mischen und zu einem dickflüssigen Sirup einkochen. Die Orangenstreifen zugeben, 5 Minuten köcheln lassen, den Sirup abgießen und die Streifen zum Trocknen auf ein Gitter legen. Nach dem Abkühlen die noch klebrigen Streifen in 100 g Zucker wälzen und trocknen lassen.

300 g frische Cranberries
250 g Zucker
1 Kardamomkapsel

Zucker und Kardamom mit 250 ml Wasser mischen und zu einem dünnflüssigen Sirup einkochen. Cranberries zugeben, einmal aufkochen und abkühlen lassen.

250 g Ricotta, 100 g Mascarpone
½ TL abgeriebene Orangenschale
½ TL Vanillearoma
2 Eier
100 g Zucker
125 ml Sahne

Ofen auf 150°C vorheizen. Alle Zutaten mischen, bis sich der Zucker auflöst und eine glatte Masse entsteht. Die Masse in 4 gefettete ofenfeste Förmchen füllen und in eine tiefe Backform setzen. Kochendes Wasser in die Backform füllen und die Cremes ca. 40–45 Minuten garen. Auskühlen lassen und mit einem scharfen Messer die Ränder lösen. Auf die Teller stürzen und mit Cranberries und Orangenstreifen garnieren.

La peau de 2 oranges, coupée en lamelles de 5 mm de large
500 g de sucre

Faire blanchir les lamelles d'orange deux à trois fois dans de l'eau bouillante. Mélanger 400 g de sucre avec 250 ml d'eau et faire réduire jusqu'à obtention d'un sirop épais. Ajouter les lamelles d'orange, faire cuire 5 minutes dans le sirop, égoutter et placer les lamelles sur une grille pour les faire sécher. Après refroidissement, rouler les lamelles collantes dans 100 g de sucre et laisser sécher.

300 g de cranberries fraîches
250 g de sucre
1 gousse de cardamome

Mélanger le sucre et la gousse de cardamome avec 250 ml d'eau et faire réduire jusqu'à obten-tion d'un sirop liquide. Ajouter les cranberries, porter à ébullition et laisser refroidir.

250 g de ricotta, 100 g de mascarpone
½ c. à café de zeste d'orange râpé
½ c. à café d'extrait de vanille
2 œufs
100 g de sucre
125 ml de crème liquide

Préchauffer le four à 150°C. Mélanger tous les ingrédients jusqu'à ce que le sucre soit dissous et que le mélange ait l'air lisse. Verser le mélange dans 4 moules à four et les placer ensuite dans un plat profond. Remplir le plat d'eau bouillante et mettre au four pendant 40 à 45 minutes. Laisser refroidir complètement et démouler les crèmes à l'aide d'un couteau pointu. Disposer sur des assiettes et garnir de cranberries et de lamelles d'orange.

2 naranjas, sólo la piel, cortada en tiras de medio centímetro
500 g de azúcar

Escaldar dos o tres veces las pieles de naranja en agua hirviendo. Combinar 400 g de azúcar y 250 ml de agua y reducir a un jarabe espeso. Añadir las pieles de naranja, cocer durante 5 minutos en el jarabe, escurrir y dejar secar las tiras sobre un estante. Después de enfriar, voltear las tiras (que estarán pegajosas) en 100 g de azúcar y dejar secar.

300 g de arándanos rojos frescos
250 g de azúcar
1 vaina de cardamomo

Combinar el azúcar y el cardamomo con 250 ml de agua y reducir a un jarabe ligero. Añadir los arándanos, llevar a ebullición y dejar enfriar.

250 g de queso ricotta, 100 g de queso mas-carpone
½ cucharadita de piel de naranja rallada
½ cucharadita de extracto de vainilla
2 huevos
100 g de azúcar
125 ml de nata

Precalentar el horno a 150°C. Combinar todos los ingredientes hasta que el azúcar se derrita y la mezcla tenga aspecto uniforme. Verter la mezcla en 4 moldes para horno engrasados y colocar en un plato profundo para horno. Rellenar el plato de agua hirviendo y cocer las crèmes durante 40–45 minutos aprox. Dejar enfriar completamente y soltar los bordes de los flanes con un cuchillo afilado. Dejar caer los flanes en los platos y adornar con los arándanos y las tiras de piel de naranja.

Buccia di 2 arance tagliata in strisce da mezzo centimetro
500 g di zucchero

Sbiancare le bucce d'arancia due o tre volte in acqua bollente. Combinare 400 g di zucchero e 250 ml d'acqua e ridurre a uno sciroppo denso. Aggiungere le bucce d'arancia, cuocere per 5 minu-ti nello sciroppo, scolare e sistemare le bucce ad asciugare su una gratella. Dopo il raffreddamento, rivoltare le bucce (che saranno appiccicose) nello zucchero rimanente e lasciare asciugare.

300 g di ribes freschi
250 g di zucchero
1 baccello di cardamomo

Combinare lo zucchero e il cardamomo con 250 ml d'acqua e ridurre a uno sciroppo leggero.

Aggiungere i ribes, portare a bollitura e lasciare raffreddare.

250 g di ricotta, 100 g di mascarpone
½ cucchiaino di buccia d'arancia grattugiata
½ cucchiaino di estratto di vaniglia
2 uova
100 g di zucchero
125 ml di panna

Preriscaldare il forno a 150°C. Combinare tutti gli ingredienti finché lo zucchero si scioglie e la mistura ha un aspetto uniforme. Versare la mistura in 4 stampi da forno e sistemare in uno stampo di cottura profondo. Riempire lo stampo d'acqua bollente e cuocere la crema per circa 40–45 minuti. Raffreddare completamente e staccare i bordi dei budini con un coltello appun-tito. Collocare sui piatti e guarnire con ribes e strisce di buccia d'arancia.

Doyers

1 Doyers Street | New York, NY 10013 | Chinatown
Phone: +1 212 513 1521
Subway: J, M, Z, N, Q, R, W, 6 Canal Street
Opening hours: Sun–Thu 11 am to 10 pm, Fri–Sat 11 am to 11 pm
Average price: $ 10
Cuisine: Vietnamese
Special features: Delivery and takeout available

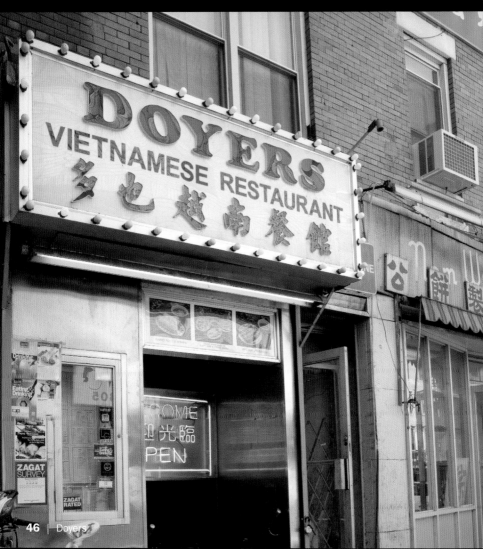

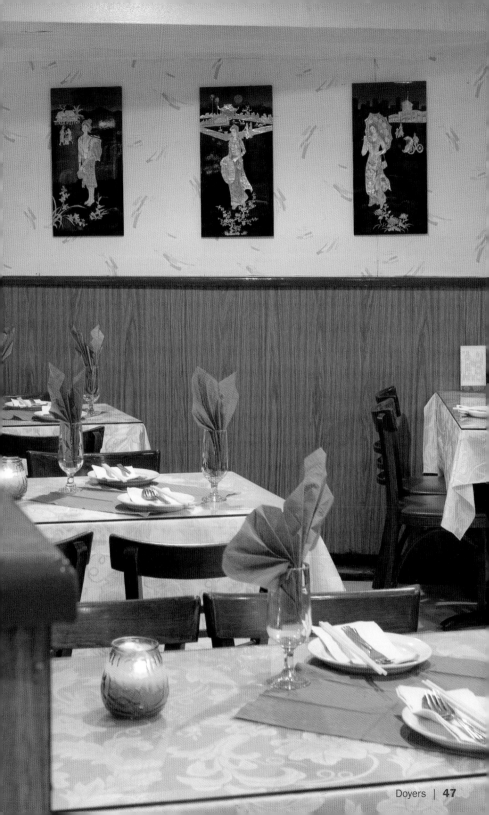

EN Japanese Brasserie

Design: Ichiro Sato AGE Designs, Adam Kushner
Chef: Koji Nakano, Yasuhiro Honma | Owners: Bunkei Yo, Reika Yo

435 Hudson Street | New York, NY 10014 | West Village
Phone: +1 212 647 9196
www.enjb.com
Subway: 1, 9 Houston Street
Opening hours: Sun–Thu 5:30 pm to 11 pm, Fri–Sat 5:30 pm to midnight
Average price: $ 58
Cuisine: Japanese
Special features: Private dining rooms

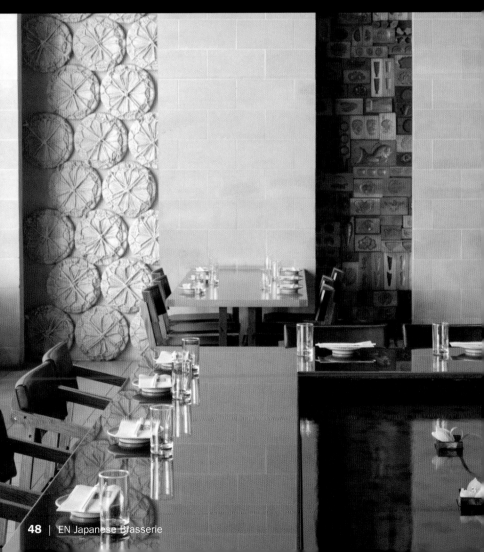

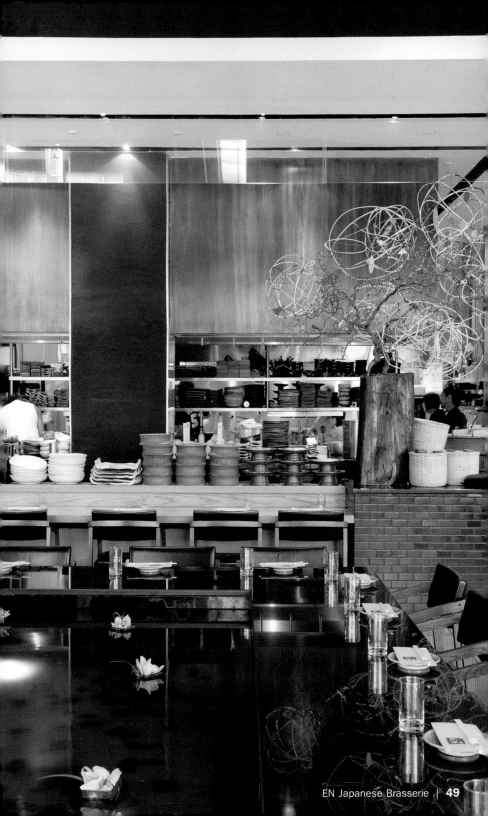

Uni Tofu

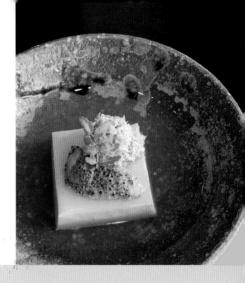

Uni-Tofu
Tofu-Uni
Uni-Tofu
Tofu di uni

3 ½ oz uni paste (sea urchin paste)
5 eggs
100 ml soy milk
160 ml dashy (Japanese broth)
1 pinch salt

Mix all ingredients, pour through a sieve and poach in a square dish for 15 minutes at 300 °F.

6 oz dashy
3 tsp mirin (sweet rice wine)
3 tsp sake
3 tsp soy sauce
2 tsp starch
1 pinch salt

Bring dashy, mirin and sake to a boil, mix starch with soy sauce and pour into the boiling liquid. Season with salt. Chill to serve, cut the uni tofu in pieces and drizzle with sauce.

100 g Uni-Paste (Seeigelpaste)
5 Eier
100 ml Sojamilch
160 ml Dashi (japanische Brühe)
1 Prise Salz

Alle Zutaten miteinander mischen, durch ein Sieb gießen und in einer rechteckigen Form 15 Minuten bei 150 °C im Wasserbad pochieren.

180 ml Dashi
3 TL Mirin (süßer Reiswein)
3 TL Sake
3 TL Sojasauce
2 TL Stärke
1 Prise Salz

Dashi, Mirin und Sake aufkochen, die Stärke mit der Sojasauce anrühren und in die kochende Flüssigkeit geben. Mit Salz abschmecken. Abkühlen lassen. Zum Servieren den Uni-Tofu in Stücke schneiden und mit der Sauce begießen.

100 g de pâte de Uni (pâte d'oursin)
5 œufs
100 ml de lait de soja
160 ml de Dashi (bouillon japonais)
1 prise de sel

Mélanger tous ces ingrédients, les passer au chinois, puis pocher au bain-marie dans un moule rectangulaire à 150 °C pendant 15 minutes.

180 ml de Dashi
3 c. à café de Mirin (vin de riz sucré)
3 c. à café de saké
3 c. à café de sauce de soja
2 c. à café de fécule
1 prise de sel

Porter à ébullition le Dashi, Mirin et saké, mélanger la fécule à la sauce de soja et ajouter dans la préparation en ébullition. Saler. Laisser refroidir. Pour servir, couper en dés le fromage de soja à la pâte d'oursin, et napper de sauce.

100 g pasta Uni (pasta de erizo de mar)
5 huevos
100 ml leche de soja
160 ml Dashi (caldo japonés)
1 pizca de sal

Mezclar todos los ingredientes, pasar a través de un colador y colocar en una forma rectangular y escalfar en baño maría por 15 minutos a 150 °C.

180 ml Dashi
3 cucharaditas de Mirin (vino dulce de arroz)
3 cucharaditas de Sake
3 cucharaditas de salsa de soja
2 cucharaditas de almidón
1 pizca de sal

Cocer Dashi, Mirin y Sake. Mezclar el almidón con la salsa de soja y agregar en el líquido hirviente. Sazonar con sal. Dejar enfriar. Para servir cortar en trozos el Uni-Tofu y regar con salsa.

100 g di pasta di uni (pasta di ricci di mare)
5 uova
100 ml di latte di soia
160 ml di dashi (brodo giapponese)
1 presa di sale

Mescolare tutti gli ingredienti, versarli attraverso un colino e affogarli in un bagno d'acqua, in uno stampo rettangolare, a 150 °C per 15 minuti.

180 ml di dashi
3 cucchiaini di mirin (vino di riso dolce)
3 cucchiaini di sakè
3 cucchiaini di salsa di soia
2 cucchiaini di amido
1 presa di sale

Far bollire il dashi, il mirin e il sakè, amalgamare l'amido con la salsa di soia e versarli nel liquido in ebollizione. Insaporire con il sale. Far raffreddare. Per servire, tagliare il tofu di uni a fette e irrorare con la salsa.

Falai

Design: Uli Wagner and Iacopo Falai | Chef: Iacopo Falai
Owner: Iacopo Falai

68 Clinton Street | New York, NY 10002 | Lower East Side
Phone: +1 212 253 1960
Subway: F Delancey Street; J, M, Z Essex Street
Opening hours: Mon–Thu 6 pm to 10:30 pm, Fri–Sat 6 pm to 11 pm, Sun 5:30 pm to
10:30 pm
Average price: $ 50
Cuisine: Italian
Special features: Outdoor dining, open kitchen, romantic atmosphere

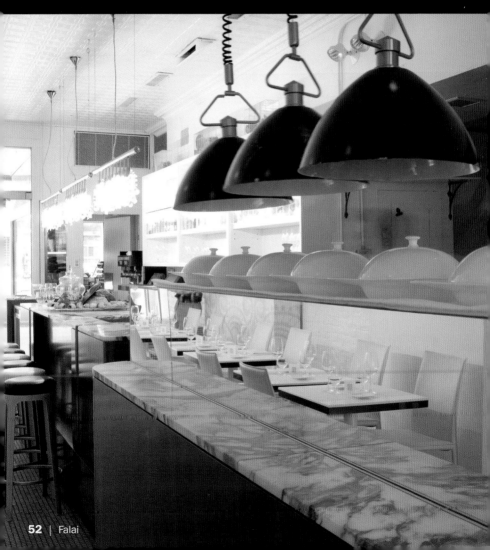

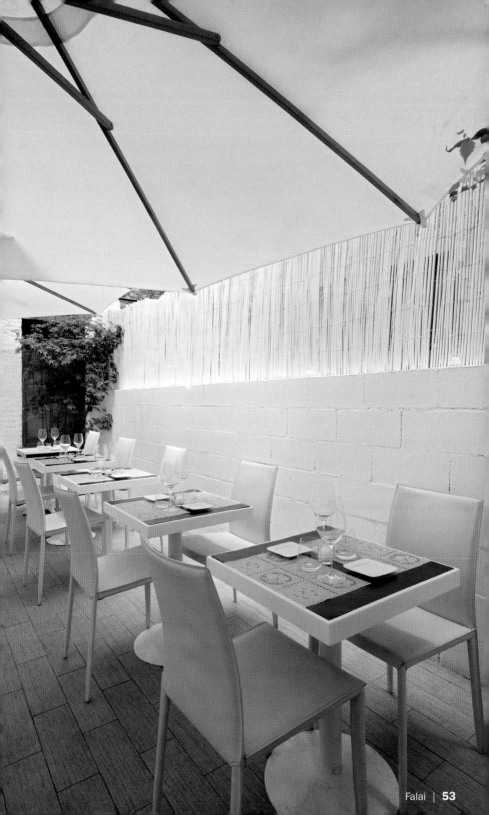

Florent

Design: Original 1949 design | **Chef:** Michael Manhertz
Owner: Florent Morellet

69 Gansevoort Street | New York, NY 10014 | Meatpacking District
Phone: +1 212 989 5779
www.restaurantflorent.com
Subway: A, C, L, E 14 Street – Eighth Avenue
Opening hours: Daily 24 hours
Average price: $ 25
Cuisine: French Bistro/Diner

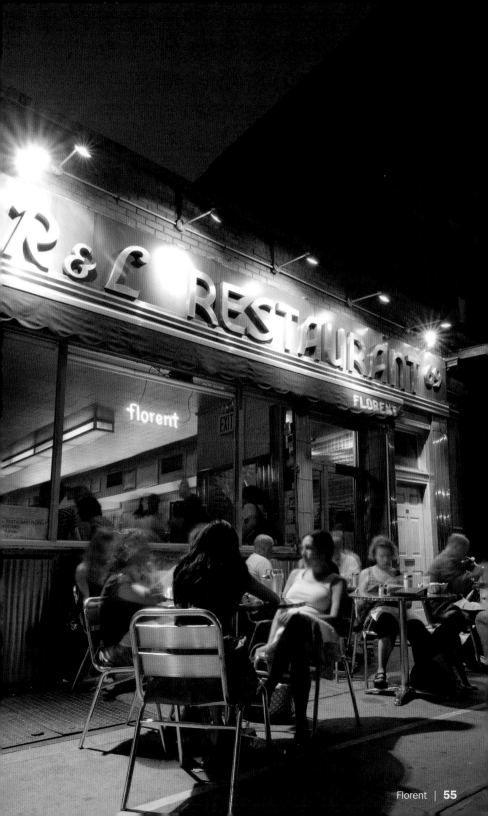

Freemans

Design: Taavo Somer | Chef: Jean Adamson
Owners: William Tigertt, Taavo Somer

191 Chrystie Street | New York, NY 10002 | Lower East Side
Phone: +1 212 420 0012
www.freemansrestaurant.com
Subway: F, V Second Avenue; J, M, Z Delancey Street; 6 Spring Street
Opening hours: Mon–Fri 11 am to 4 pm, 6 pm to 11:30 pm,
Sat–Sun 11 am to 3:30 pm
Average price: $ 15
Cuisine: Traditional rustic American

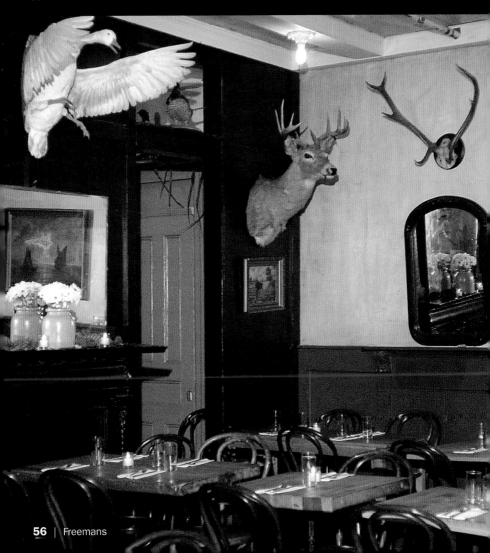

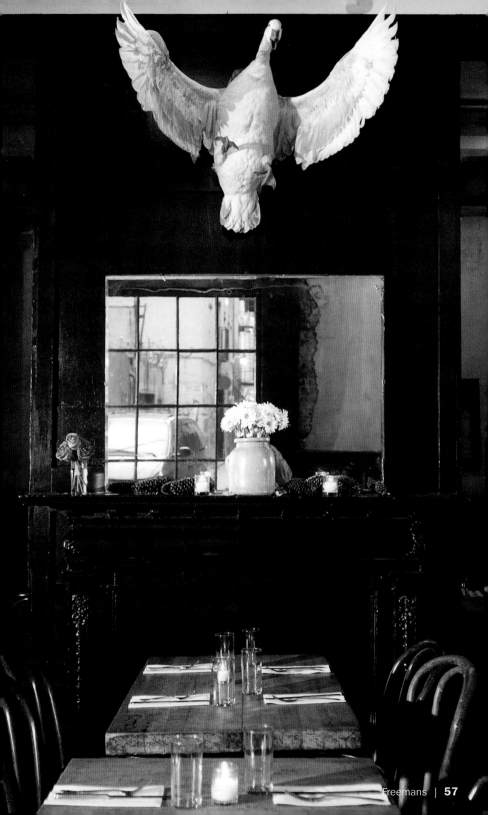

Ginger

Design: Andrew Phillips | Consulting Chef: Rosa Losan Ross
Owner: Michelle Jean

1400 Fifth Avenue | New York, NY 10026 | Harlem
Phone: +1 212 423 1111
www.gingerexpress.com
Subway: 2, 3 116 Street – Lenox Avenue; 6 116 Street – Lexington Avenue
Opening hours: Mon–Thu 5:30 pm to 10:30 pm, Fri–Sat 5:30 pm to 11:30 pm,
Sun 5:30 pm to 10 pm, bar opens daily at 5 pm, daily take out & delivery 5 pm to 10 pm
Average price: $ 25
Cuisine: Healthy Chinese
Special features: Cubist dragon bar and light box

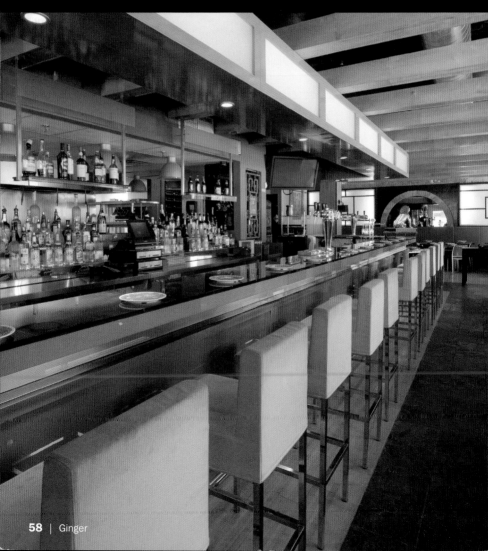

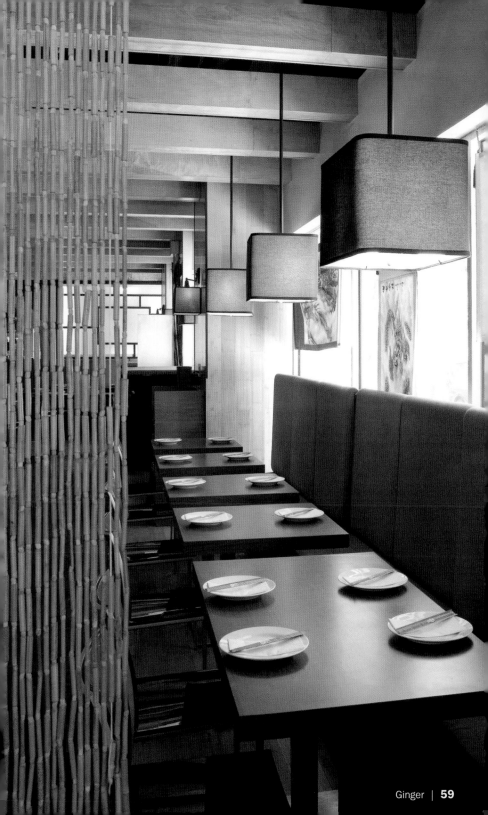

Indochine

Design: Aero Studios | Chef, Owner: Huy Chi Le

430 Lafayette Street | New York, NY 10003 | NoHo
Phone: +1 212 505 5111
indochinenyc@aol.com
Subway: 6 Astor Place
Opening hours: Sun–Wed 5:30 pm to 11:30 pm, Thu–Sat 5:30 pm to midnight
Average price: $ 55
Cuisine: Asian, French, Vietnamese

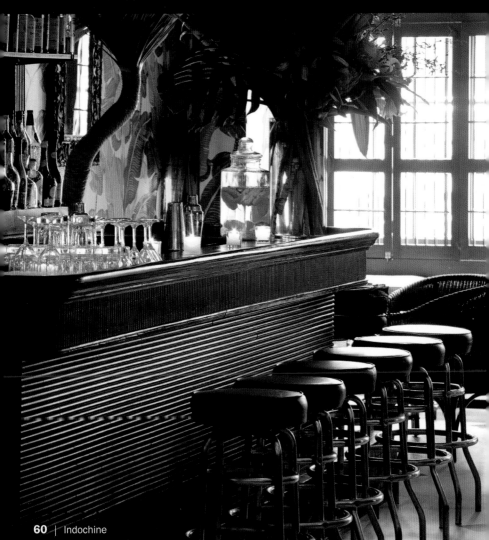

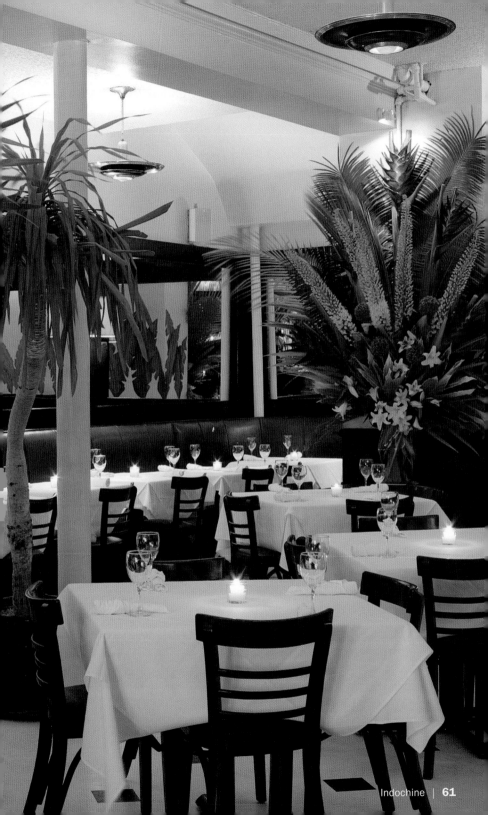

Bouillabaisse

Broth:
1 l fish broth
500 ml coconut milk
1 tsp shrimp paste
2 tbsp garlic-chili-paste
5 tbsp fish sauce
4 tbsp tomato paste
1 tbsp sugar
2 tbsp Kaffir lime leaves, chopped
1 tsp curry powder

24 fresh mussels, cleaned
12 prawns, shelved and deveined
8 oz octopus rings
8 oz scallop meat
7 oz cabbage

2 shallots, chopped and sauted
Asian basil and lime slices for decoration

Combine all ingredients for the broth, except for curry and lime leaves, in a pot and bring to a boil. Add curry and lime leaves, let it simmer on low heat for 10 minutes. Season. Add the mussels and let simmer for 3 minutes, then add the other seafood and simmer for another 2 minutes. Divide cabbage and seafood amongst 4 bowls and pour the soup on top. Garnish with basil, shallots and lime slices.

Brühe:
1 l Fischfond
500 ml Kokosnussmilch
1 TL Krabbenpaste
2 EL Knoblauch-Chili-Paste
5 EL Fischsauce
4 EL Tomatenmark
1 EL Zucker
2 EL Kaffernlimettenblätter, fein gehackt
1 TL Currypulver

24 frische Miesmuscheln, gewaschen
12 Garnelen, ohne Schalen und ausgenommen
250 g Tintenfischringe
250 g Jakobsmuschelfleisch
200 g Chinakohl, fein gehackt

2 Schalotten, gehackt und angebraten
Asiatisches Basilikum und Limonenscheiben zur Dekoration

Alle Zutaten für die Brühe, bis auf Curry und Limettenblätter, in einen Topf geben und einmal aufkochen lassen. Curry und Limettenblätter zufügen, die Brühe bei kleiner Hitze 10 Minuten köcheln lassen, abschmecken. Die Miesmuscheln zugeben und 3 Minuten mitköcheln, die restlichen Meeresfrüchte in die Suppe geben und weitere 2 Minuten garen. Chinakohl und Meeresfrüchte auf 4 Schalen verteilen und die Suppe darauf geben. Mit Basilikum, Schalotten und Limonenscheiben garnieren.

Bouillon :
1 l de bouillon de poisson
500 ml de lait de coco
1 c. à café de pâte de crevette
2 c. à soupe de pâte de chili à l'ail
5 c. à soupe de nuoc-mâm
4 c. à soupe de concentré de tomate
1 c. à soupe de sucre
2 c. à soupe de feuilles de combava émincées
1 c. à café de curry en poudre

24 moules fraîches nettoyées
12 gambas décortiquées et dont on aura ôté la
veine dorsale
250 g d'anneaux de calamars
250 g de noix de St-Jacques
200 g de chou chinois émincé

2 échalotes hachées et sautées
Basilic thaï et rondelles de citron vert (pour la
présentation)

Mettre tous les ingrédients du bouillon, sauf le
curry et les feuilles de combava, dans une cas-
serole, et porter à ébullition. Ajouter le curry et
les feuilles de combava et laisser mijoter à feu
doux pendant 10 minutes. Assaisonner. Ajouter
les moules et laisser 3 minutes sur le feu,
puis ajouter les autres fruits de mer et laisser
mijoter encore 2 minutes. Répartir le chou et
les fruits de mer dans 4 bols et verser la soupe
par-dessus. Garnir de basilic, d'échalotes et de
rondelles de citron vert.

Caldo:
1 l de caldo de pescado
500 ml de leche de coco
1 cucharadita de pasta de gambas
2 cucharadas de salsa de ajo y chili
5 cucharadas de salsa de pescado
4 cucharadas de pasta de tomate
1 cucharada de azúcar
2 cucharadas de hojas de lima kaffir troceadas
1 cucharadita de curry en polvo

24 mejillones frescos y lavados
12 camarones pelados y desvenados
250 g de anillos de pulpo
250 g de vieiras
200 g de coles

2 chalotas picadas y salteadas
Albahaca asiática y rebanadas de lima para
decoración

Combinar todos los ingredientes del caldo en
una cazuela, salvo el curry y la hojas de lima,
y llevar a ebullición. Añadir el curry y la lima y
dejar cocer a fuego lento durante 10 minutos.
Aderezar. Añadir los mejillones y dejar cocer
durante 3 minutos, luego añadir lo que queda
de marisco y cocer durante 2 minutos más.
Repartir las coles y los mariscos entre 4 cuen-
cos y verter la sopa encima. Adornar con la
albahaca, la chalota y las rebanadas de lima.

Brodo:
1 l di brodo di pesce
500 ml di latte di cocco
1 cucchiaino di pasta di gamberetti
2 cucchiai di pasta di chili all'aglio
5 cucchiai di salsa di pesce
4 cucchiai di concentrato di pomodoro
1 cucchiaio di zucchero
2 cucchiai di foglie di lime kaffir sminuzzate
1 cucchiaino di polvere di curry

24 cozze fresche e pulite
12 gamberetti sgusciati e svenati
250 g di anelli di seppia
250 g di cappesante
200 g di cavoli cinesi sminuzzati

2 cuori di scalogno tritati e saltati
Basilico asiatico e lime a fette per la decora-
zione

Combinare tutti gli ingredienti del brodo esclusi
il curry e le foglie di lime in una pentola e por-
tare a bollitura. Aggiungere il curry e il lime e
cuocere a fuoco lento per 10 minuti. Condire.
Aggiungere le cozze e lasciare cuocere sempre
a fuoco lento per 3 minuti, poi aggiungere gli
altri frutti di mare e cuocere ancora 2 minuti.
Ripartire i cavoli e i frutti di mare in 4 scodelle e
versarci sopra la zuppa. Guarnire con il basilico,
lo scalogno e le fette di lime.

Keens Steakhouse

Design, Owners: Dr. George Schwarz, Kiki Kogelnik
Chef: Bill Rodgers

72 West 36 Street | New York, NY 10018 | Midtown West
Phone: +1 212 947 3636
www.keens.com
Subway: B, D, F, N, Q, R, V, W 34 Street – Sixth Avenue
Opening hours: Mon–Fri 11:45 am to 3 pm, 5:30 pm to 10:30 pm,
Sat 5 pm to 10:30 pm, Sun 5 pm to 9 pm
Average price: Lunch $ 30, dinner $ 65
Cuisine: American
Special features: Various dining rooms for events & private parties

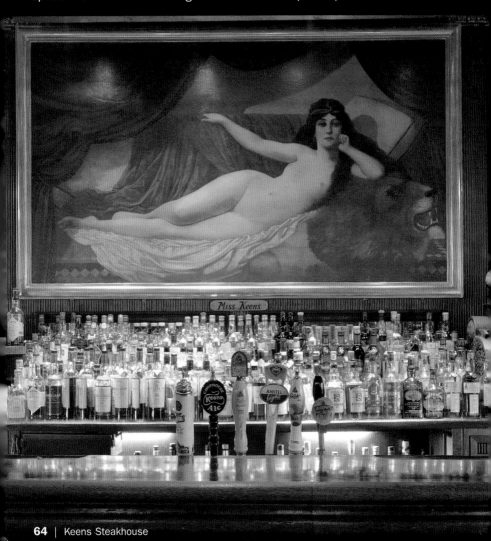

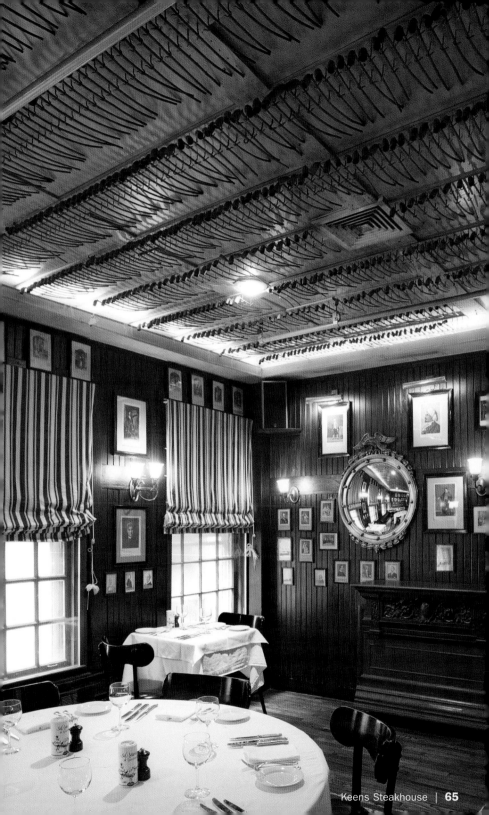

Porterhouse Steak

Porterhouse Steak

Steaks Porterhouse

Bistec Porterhouse

Bistecca Porterhouse

2 Porterhouse Steaks, 2 lb each
Salt
4 tbsp vegetable oil

Take the meat out of the refrigerator 20 minutes prior to cooking and allow it come to room temperature. Preheat the oven to 360°F.
Pat the meat dry and season generously with salt. Heat a pan until very hot, add the oil and sear the meat from both sides.
Place the meat in the oven and braise to the desired degree of doneness with the help of a meat thermometer (115°F means medium rare).

Set the grease in the pan aside. Remove the meat from the oven and let rest for 10 minutes. Cut the meat in slices, save the meat juices and arrange the meat on warm plates. Pour the juices back into the pan, bring to a boil and drizzle over the meat. Serve immediately.
Baked potatoes, herb butter and steamed vegetables or a salad go well with this dish.

2 Porterhouse Steaks à 1 kg
Salz
4 EL Pflanzenöl

20 Minuten vor der Zubereitung das Fleisch aus dem Kühlschrank nehmen, damit es Zimmertemperatur annimmt. Den Ofen auf 180°C vorheizen.
Das Fleisch trocken tupfen und kräftig mit Salz würzen. Eine Pfanne sehr heiß werden lassen, das Öl hineingeben und das Fleisch von beiden Seiten kräftig anbraten.
Das Fleisch in den Ofen geben und mit Hilfe eines Fleischthermometers zur gewünschten Garstufe garen (45°C Kerntemperatur bedeutet medium).

Das Fett in der Pfanne beiseite stellen. Das Fleisch aus dem Ofen nehmen und 10 Minuten ruhen lassen. Das Fleisch in Tranchen schneiden, die Fleischsäfte auffangen und das Fleisch auf vorgewärmten Tellern anrichten. Die Fleischsäfte zurück in die Pfanne geben, einmal aufkochen und über das Fleisch gießen. Sofort servieren.
Dazu passen Ofenkartoffeln, Kräuterbutter und gedünstetes Gemüse oder ein bunter Salat.

2 steaks Porterhouse d'un kg chacun
Sel
4 c. à soupe d'huile végétale

Sortir la viande du réfrigérateur 20 minutes avant la cuisson pour qu'elle soit à la température de la pièce. Préchauffer le four à 180°C.
Essuyer la viande et la saler généreusement. Faire chauffer une poêle et saisir la viande des deux côtés à feu très vif.
Mettre la viande au four et cuire jusqu'au degré de cuisson souhaité à l'aide d'un thermomètre à viande (45°C pour une viande à point).

Mettre la matière grasse dans la poêle. Enlever la viande du four et la laisser reposer 10 minutes. Couper la viande en tranches, garder le jus de cuisson et disposer la viande sur des assiettes chaudes. Verser le jus de viande dans la poêle, porter à ébullition et verser sur la viande. Servir immédiatement.
Pommes de terre au four, beurre d'herbes, légumes vapeur et salade accompagnent parfaitement ce plat.

2 bistecs Porterhouse de 1 kg cada uno
Sal
4 cucharadas de aceite vegetal

Sacar la carne de la nevera 20 minutos antes de cocinar y dejar que se ponga a temperatura ambiente. Precalentar el horno a 180°C.
Secar la carne golpeándola ligeramente y salarla generosamente. Calentar una sartén a temperatura muy alta, añadir el aceite y abrasar la carne por ambos lados.
Poner la carne en el horno y cocer al nivel de cocción deseado, con la ayuda de un termómetro para carne (45°C significa que la carne está medianamente hecha).

Quitar la grasa de la sartén y guardarla. Quitar la carne del horno y dejar reposar durante 10 minutos. Cortar la carne en rebanadas, guardar el jugo y disponer la carne en platos calientes. Verter todos los jugos y las grasas otra vez en la sartén, llevar a ebullición y rociar sobre la carne. Servir inmediatamente.
El plato se acompaña bien con patatas al horno, mantequilla de hierbas y verduras al vapor o ensalada.

2 bistecche Porterhouse da 1 kg ciascuna
Sale
4 cucchiai di olio vegetale

Togliere la carne dal frigorifero 20 minuti prima di cucinarla, portandola così a temperatura ambiente. Preriscaldare il forno a 180°.
Asciugare la carne battendola con cura, quindi salarla generosamente. Riscaldare una padella a temperatura molto alta, aggiungere l'olio e scottare la carne su entrambi i lati.
Mettere la carne in forno e brasare al livello di cottura desiderato, con l'aiuto di un termometro per carni (45°C corrispondono a una cottura media).

Mettere da parte il grasso che si trova nella padella. Togliere la carne dal forno e lasciare riposare per 10 minuti. Tagliare la carne a fette, conservare il sugo e disporre la carne sui piatti caldi. Versare di nuovo i sughi in padella, fare bollire e spargere sulla carne. Servire immediatamente.
Il piatto si accompagna bene con patate al forno, burro alle erbe e verdure al vapore o insalata assortita.

Kobe Club

Design: Dodd Mitchell Designs | Chef: Russell Titland
Owner: Jeffrey Chodorow, China Grill Management

68 West 58th Street | New York, NY 10019 | Midtown
Phone: +1 212 644 5623
www.chinagrillmgt.com
Subway: F 57 Street
Opening hours: Mon–Wed 5:30 pm to 11 pm, Thu–Sat 5:30 pm to 11:30 pm
Average price: $ 90
Cuisine: Kobe steak house
Special features: Specialty cocktails and games

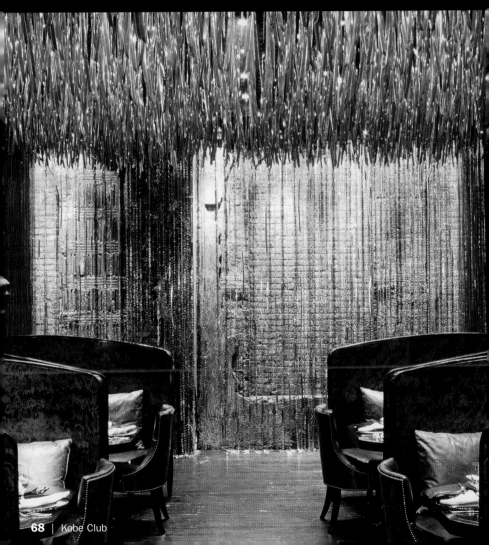

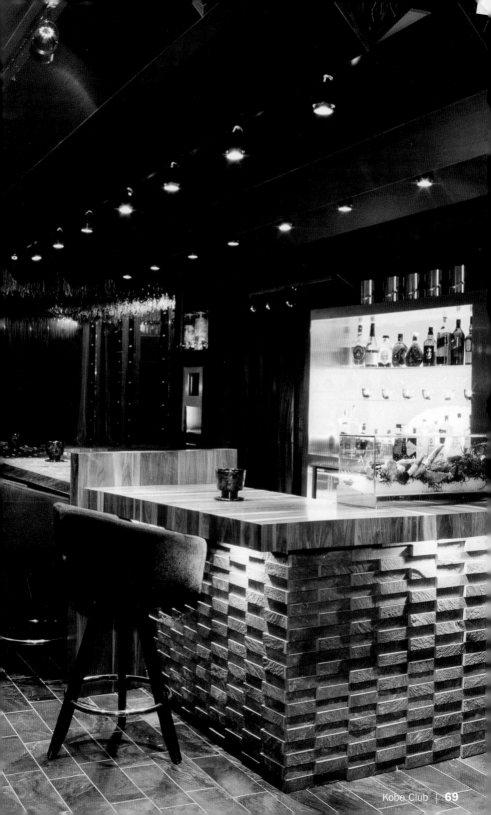

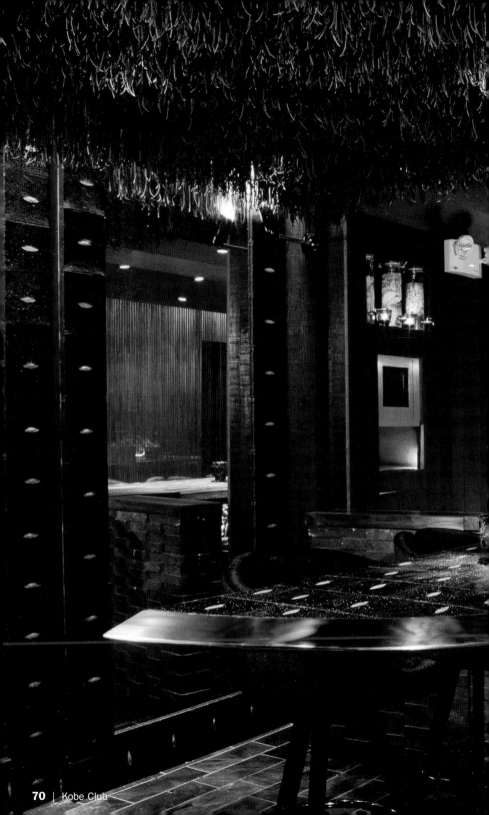

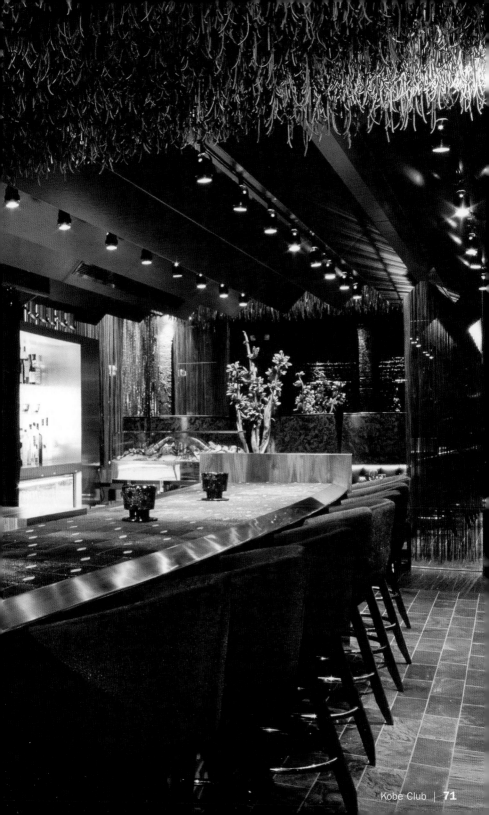

La Esquina

Design: Serge Becker | Chef: Rene Ortiz | Owners: James Gersten, Derek Sanders, Serge Becker and Cordell Lochin

106 Kenmare Street | New York, NY 10012 | NoLIta
Phone: +1 646 613 7100
www.esquinanyc.com
Subway: 6 Spring Street
Opening hours: Mon–Fri Taqueria 8 am to 5 am, Café noon to midnight, Brasserie 6 pm to 2 am, Sat–Sun Taqueria from noon to 5 am, Café 11 am to midnight, Brasserie 6 pm to 2 am
Average price: Taqueria $ 5, Café $ 11, Brasserie $ 18
Cuisine: Mexican
Special features: "Hidden" dining room, three restaurants in one, extensive tequila list

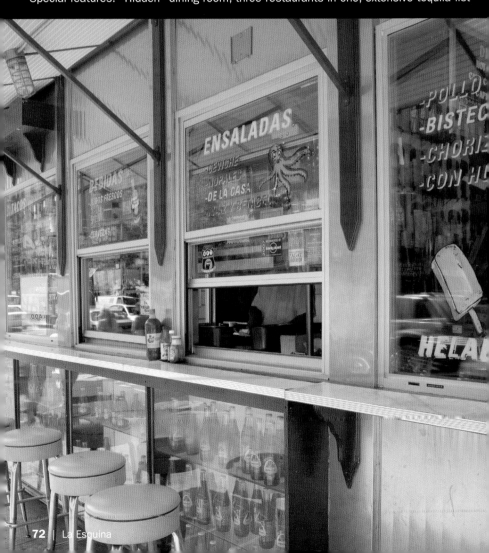

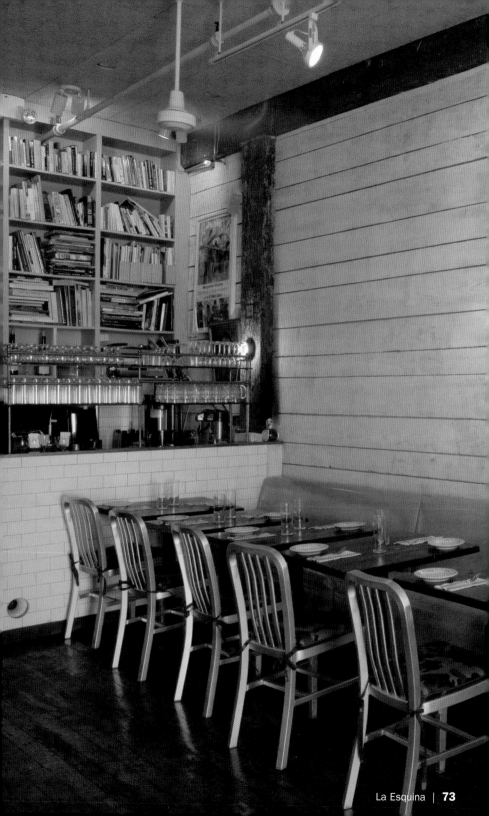

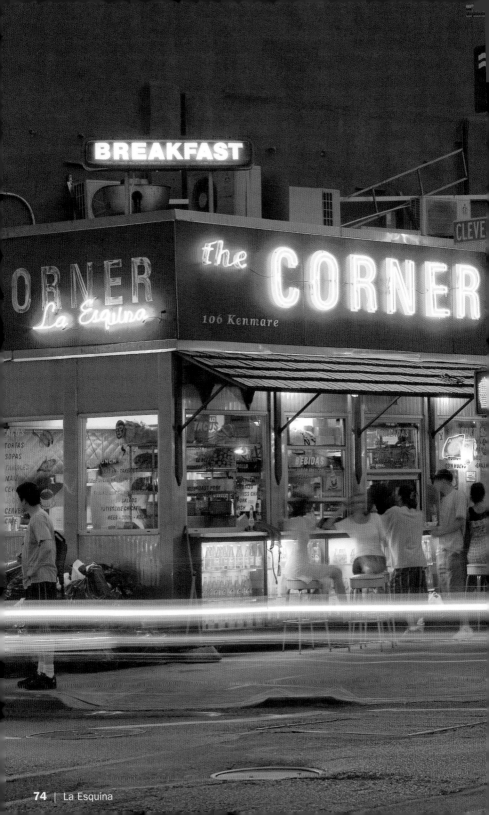

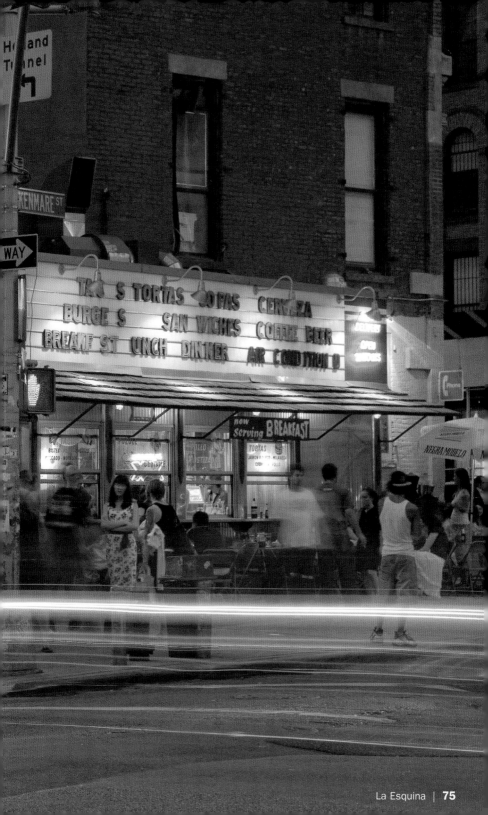

Lever House Restaurant

Design: Marc Newson | Chef: Dan Silverman
Owners: Joshua Pickard, John McDonald

390 Park Avenue | New York, NY 10022 | Midtown East
Phone: +1 212 888 2700
www.leverhouse.com
Subway: E, V Lexington Avenue – 53 Street; 6 51 Street
Opening hours: Mon–Fri 11:45 am to 2 pm, 5:30 pm to 10:30 pm,
Fri–Sat 5:30 pm to 11 pm
Average price: $ 17
Cuisine: Country Club inspired American
Special features: The Lever House courtyard and terrace accomodate up to 750 people

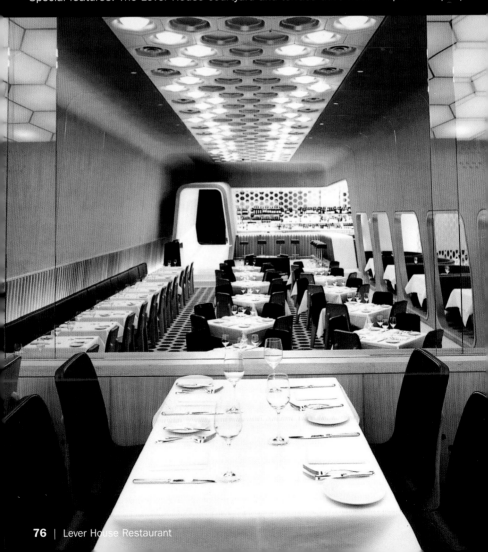

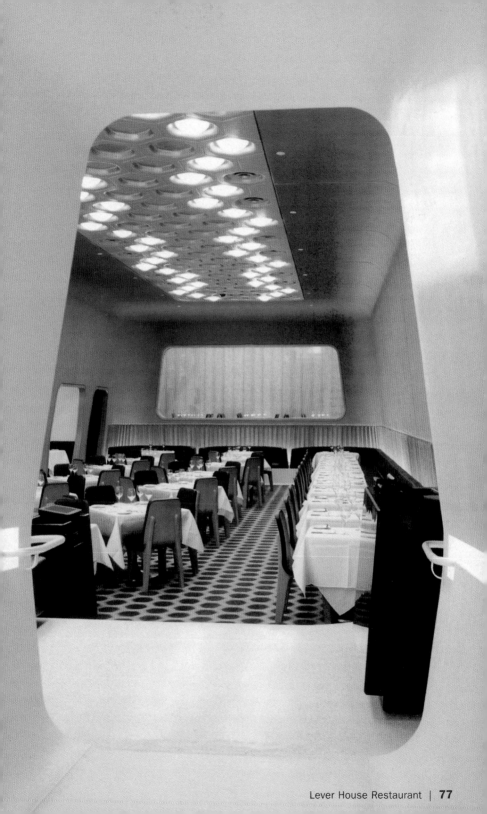

Pork Chops

with Apple Jus

Schweinekoteletts mit Apfelsauce
Côtelettes de porc sauce aux pomme
Chuletas de cerdo con salsa de manzana
Braciole al succo di mele

4 l water
10 oz sugar
4 oz salt
3 bay leaves, juniper berries, garlic cloves and
cloves each and 1 tbsp paprika
4 pork chops

Bring water and seasonings to aboil and chill.
Marinate the chops over night.

1 tsp pimento
2 tbsp coriander seeds
1 tsp cumin
1 tbsp juniper berries
1 tsp black pepper

Toast all spices and grind medium fine. Toss the
marinated pork chops in the seasoning and sear

from both sides. Bake at 360°F in an oven for
approx. 10 minutes until done.

350 ml organic apple juice
2 cardamom pods
1 stick cinnamon
Salt, pepper
2 apples, seeded and roughly diced
2 tbsp pomegranate syrup

Combine apple juice, cardamom, cinnamon, salt
and pepper and reduce to a half by simmering.
Add the diced apples, cover and let simmer for
30 minutes. Pour through a strainer, season
again, if necessary and finish at last with pome-
granate syrup.
A yam casserole goes well with this dish.

4 l Wasser
300 g Zucker
120 g Salz
Jeweils 3 Lorbeerblätter, Wacholderbeeren,
Knoblauchzehen, Nelken und 1 EL
Paprikapulver
4 Schweinekoteletts

Wasser und Gewürze einmal aufkochen und
abkühlen lassen. Die Koteletts über Nacht
einlegen.

1 TL Piment
2 EL Koriandersamen
1 TL Kreuzkümmel
1 EL Wacholderbeeren
1 TL schwarzer Pfeffer

Alle Gewürze rösten und mittelfein mahlen. Die
eingelegten Koteletts darin wälzen und von bei-
den Seiten anbraten. Bei 180°C ca. 10 Minuten
im Ofen durchgaren.

350 ml Apfelsaft
2 Kardamomkapseln
1 Zimtstange
Salz, Pfeffer
2 Äpfel, entkernt, grob gewürfelt
2 EL Granatapfelsirup

Apfelsaft, Kardamom, Zimt, Salz und Pfeffer
mischen und auf die Hälfte einkochen las-
sen. Die Apfelstücke zugeben und abgedeckt
30 Minuten köcheln lassen. Durch ein Sieb pas-
sieren, evtl. noch einmal abschmecken und ganz
zum Schluss mit Granatapfelsirup verfeinern.
Zu diesem Gericht passt ein Süßkartoffelauflauf

4 l d'eau
300 g de sucre
120 g de sel
3 feuilles de laurier, 3 baies de genièvre, 3 gousses
d'ail, 3 clous de girofle et 1 c. à soupe de paprika
4 côtelettes de porc

Porter l'eau et l'assaisonnement à ébullition
et laisser refroidir. Faire mariner les côtelettes
toute la nuit dans ce mélange.

1 c. à café de piment
2 c. à soupe de graines de coriandre
1 c. à café de cumin
1 c. à soupe de baies de genièvre
1 c. à café de poivre noir

Faire griller toutes les épices et les moudre
assez fin. Tremper les côtelettes de porc mari-
nées dans l'assaisonnement et les saisir des
deux côtés. Faire à cuire au four à 180°C pen-
dant environ 10 minutes.

350 ml de jus de pomme bio
2 gousses de cardamome
1 bâton de cannelle
Sel, poivre
2 pommes épépinées et coupées en dés grossiers
2 c. à soupe de sirop de grenadine

Mettre dans une casserole le jus de pomme, la
cardamome, la cannelle, le sel et le poivre et faire
réduire de moitié. Ajouter les dés de pomme,
couvrir et laisser mijoter 30 minutes. Passer au
chinois, rectifier l'assaisonnement si nécessaire,
et ajouter enfin le sirop de grenadine.
Un ragoût de patates douces se marie très bien
avec ce plat.

4 l de agua
300 g de azúcar
120 g de sal
3 hojas de laurel, bayas de junípero, dientes de
ajo y clavillos y 1 cucharada de páprika
4 chuletas de cerdo

Llevar a ebullición el agua y los condimentos y
dejar resfriar. Marinar las chuletas durante la
noche.

1 cucharadita de pimienta de Jamaica
2 cucharadas de semillas de cilantro
1 cucharadita de comino
1 cucharada de bayas de junípero
1 cucharadita de pimienta negra

Tostar todas las especias y moler medio-fina-
mente. Voltear las chuletas marinadas en el
condimento y abrasar por ambos lados. Cocer
en el horno a 180°C durante 10 minutos aprox.,
hasta que estén hechas.

350 ml de zumo de manzana orgánica
2 vainas de cardamomo
1 barrita de canela
Sal y pimienta
2 manzanas sin semillas y troceadas en cubos
2 cucharadas de jarabe de granadina

Combinar el zumo de manzana, el cardamomo,
la canela, la sal y la pimienta y reducir a la mitad
cociendo a fuego lento. Añadir las manzanas tro-
ceadas, cubrir y dejar cocer a fuego lento duran-
te 30 minutos. Pasar por un colador, aderezar
otra vez si es necesario, y acabar finalmente con
el jarabe de granadina.
El plato se acompaña bien con boniatos en
cacerola.

4 l d'acqua
300 g di zucchero
120 g di sale
3 foglie d'alloro, bacche di ginepro, spicchi
d'aglio e chiodi di garofano e 1 cucchiaio di
paprika
4 braciole

Portare a bollitura l'acqua e i condimenti e
lasciare raffreddare. Marinare le braciole per
tutta la notte.

1 cucchiaino di pimento
2 cucchiai di semi di coriandolo
1 cucchiaino di cumino
1 cucchiaio di bacche di ginepro
1 cucchiaino di pepe nero

Tostare le spezie e macinarle medio-finemente.
Rigirare le braciole marinate nel condimento e
scottare su entrambi i lati. Cuocere in forno a
180°C per circa 10 minuti fino a cottura.

350 ml di succo di mele organico
2 baccelli di cardamomo
1 bastoncino di cannella
Sale e pepe
2 mele senza semi, tagliate a pezzettini
2 cucchiai di sciroppo di granatina

Combinare il succo di mele, il cardamomo,
la cannella, il sale e il pepe e ridurre a metà
cuocendo a fuoco lento. Aggiungere le mele a
pezzi coprire e lasciare cuocere per 30 minuti.
Passare con un colino, eventualmente condire di
nuovo e rifinire definitivamente con lo sciroppo
di granatina.
Il piatto si accompagna bene con patate dolci
in casseruola.

Lure Fishbar

Design: Serge Becker, Derek Sanders | Chef: Josh Capon
Owners: Joshua Pickard, John McDonald

142 Mercer Street | New York, NY 10012 | SoHo
Phone: +1 212 431 7676
www.lurefishbar.com
Subway: B, D, F, V Broadway – Lafayette Street; R, W Prince Street; 6 Bleecker Street –
Spring Street
Opening hours: Sun–Thu 11:30 am to 11 pm, Fri–Sat 11:30 am to midnight
Average price: $ 26
Cuisine: Seafood
Special features: Private room for special events

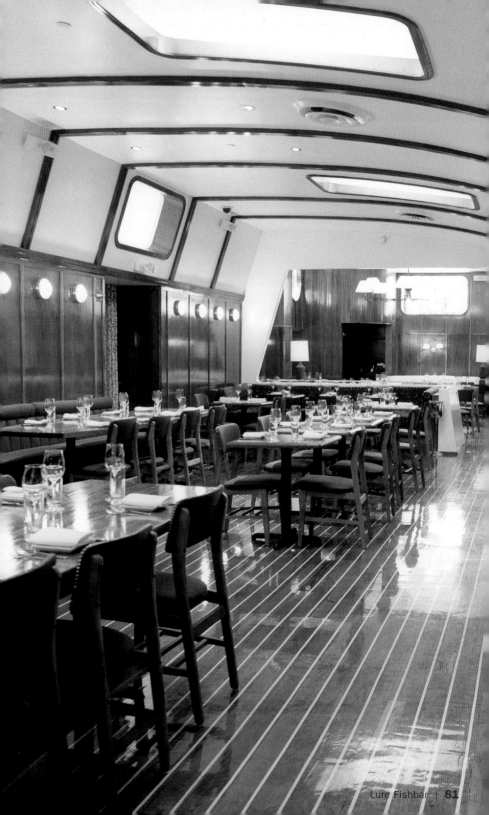

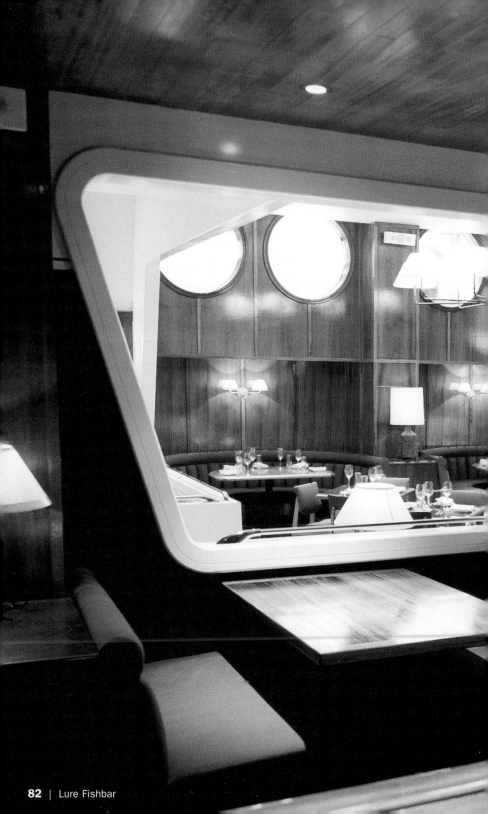

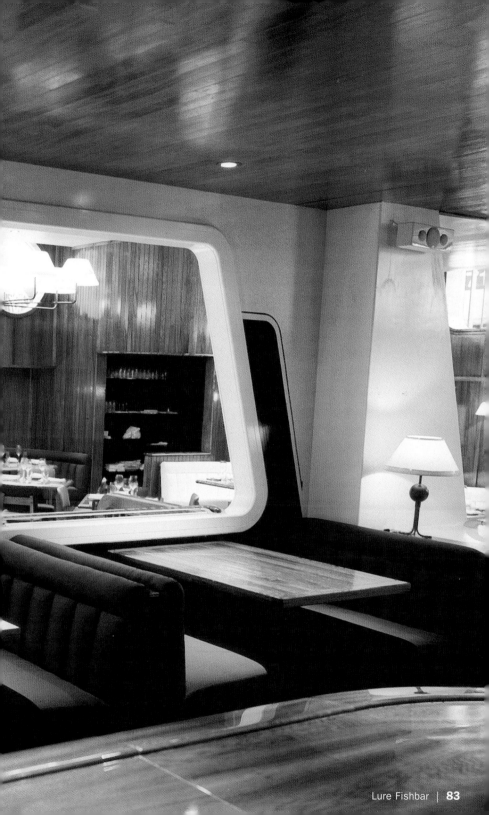

Grilled Swordfish
with Soy Butter and Tomato Salad

Gegrillter Schwertfisch mit Sojabutter und Tomatensalat

Espadon grillé avec beurre de soja et salade de tomates

Pez espada a la parrilla con mantequilla de soja y ensalada de tomates

Pescespada alla griglia con burro di soia e insalata di pomodori

4 swordfish fillets, 6 oz each
Salt, pepper
6 oz butter
4 oz soy powder
1 clove of garlic
1 tsp ginger, peeled
6 large tomatoes
1 clove of garlic, chopped
1 shallot, diced
3 tbsp red wine vinegar
3 tbsp olive oil
Cress

Puree soy powder, garlic and ginger in a blender and mix with butter. Marinade the fish in the butter. Peel tomatoes, discard the seeds and cut in bite-size pieces, drain the juice. Sauté the garlic and shallot cubes, combine with the tomato pieces and season with vinegar, oil, salt and pepper. Remove the swordfish from the butter, season with salt and pepper and grill for 3 minutes from each side on a char-coal grill.
Cut each fillet into 5 pieces, arrange on the tomato salad and garnish with some cress.

4 Schwertfischfilets, à 180 g
Salz, Pfeffer
180 g Butter
120 g Sojapulver
1 Knoblauchzehe
1 TL Ingwer, geschält
6 große Tomaten
1 Knoblauchzehe, gewürfelt
1 Schalotte, gewürfelt
3 EL Rotweinessig
3 EL Olivenöl
Kresse

Sojapulver, Knoblauch und Ingwer in einem Mixer pürieren und mit der Butter mischen. Den Fisch in der Butter einlegen. Tomaten schälen, entkernen und in mundgerechte Stücke schneiden, den Saft abtropfen lassen. Knoblauch- und Schalottenwürfel anschwitzen, mit den Tomatenstücken mischen und mit Essig, Öl, Salz und Pfeffer abschmecken. Den Schwertfisch aus der Butter nehmen, mit Salz und Pfeffer würzen und 3 Minuten auf jeder Seite auf einem Holzkohlegrill grillen.
Jedes Filet in 5 Stücke schneiden, auf dem Tomatensalat anrichten und mit etwas Kresse garnieren.

4 filets d'espadon de 180 g
Sel, poivre
180 g de beurre
120 g de soja en poudre
1 gousse d'ail
1 c. à café de gingembre épluché
6 grosses tomates
1 gousse d'ail coupée en dés
1 échalote en dés
3 c. à soupe de vinaigre de vin rouge
3 c. à soupe d'huile d'olive
Cresson

Passer au mixeur la poudre de soja, l'ail et le gingembre, puis mélanger au beurre. Déposer le poisson dans le beurre. Eplucher les tomates, retirer les pépins et les couper en bouchées, laisser égoutter le jus. Frire les dés d'ail et d'échalotes, puis les mélanger aux morceaux de tomates et assaisonner à l'huile et au vinaigre et au sel et poivre. Retirer l'espadon du beurre, saler et poivrer et passer les filets au grill à charbon de bois 3 minutes des deux côtés. Découper chaque filet en 5 morceaux, les disposer sur la salade de tomates et garnir avec un peu de cresson.

4 filetes de pez espada de 180 g
Sal, pimienta
180 g de mantequilla
120 g de polvo de soja
1 diente de ajo
1 cucharadita de jengibre pelado
6 tomates grandes
1 diente de ajo cortado en dados
1 chalote cortado en dados
3 cucharadas de vinagre de vino tinto
3 cucharadas de aceite de oliva
Berro

Picar en una batidora el polvo de soja, ajo y jengibre y mezclar con la mantequilla. Colocar el pescado en la mantequilla. Pelar los tomates, sacar las semillas y cortar en pedazos apropiados para llevar a la boca, dejar gotear el jugo. Freír los dados de ajo y chalote, mezclar con los trozos de tomate y aderezar con vinagre, aceite, sal y pimienta. Sacar el pez espada de la mantequilla, aderezar con sal y pimienta y colocar en la parrilla calentada con carbón vegetal por 3 minutos de cada lado.
Cortar cada filete en 5 piezas, servir sobre la ensalada de tomates y adornar con un poco de berro.

4 filetti di pescespada da 180 g
Sale, pepe
180 g di burro
120 g di soia in polvere
1 spicchio di aglio
1 cucchiaino di zenzero sbucciato
6 pomodori grandi
1 spicchio di aglio tagliato a dadini
1 scalogno tagliato a dadini
3 cucchiai di aceto di vino rosso
3 cucchiai di olio d'oliva
Crescione

Passare la soia in polvere, l'aglio e lo zenzero in un mixer e mescolare con il burro. Mettere il pesce nel burro. Pelare i pomodori, rimuovere il nucleo e tagliare a pezzetti; fare sgocciolare il succo. Imbiondire i dadini d'aglio e di scalogno, mescolare con i pezzetti di pomodoro e condire con aceto, olio, sale e pepe. Togliere il pescespada dal burro, insaporire con sale e pepe e grigliare ciascun lato per 3 minuti con un grill a carbone di legna.
Tagliare ogni filetto in 5 pezzi, disporli sull'insalata di pomodori e guarnire con un po' di crescione.

Matsuri

Design, Owners: Sean MacPherson and Eric Goode in collaboration
with Mikio Shinagawa | Chef: Tadashi Ono

369 West 16th Street | New York, NY 10011 | Chelsea
Phone: +1 212 243 6400
www.themaritimehotel.com
Subway: A,C,E, L 14 Street – Eighth Avenue
Opening hours: Sun–Wed 6 pm to 1:30 am, Thu–Sat 6 pm to 2:30 am
Average price: $ 55
Cuisine: Japanese
Special features: Sake bar, 200+ of the finest and rarest sakes

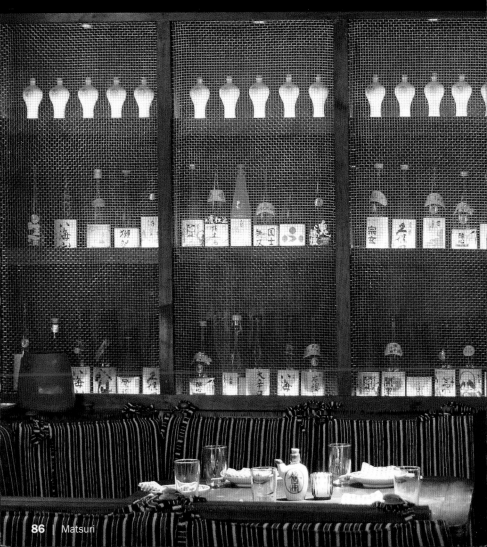

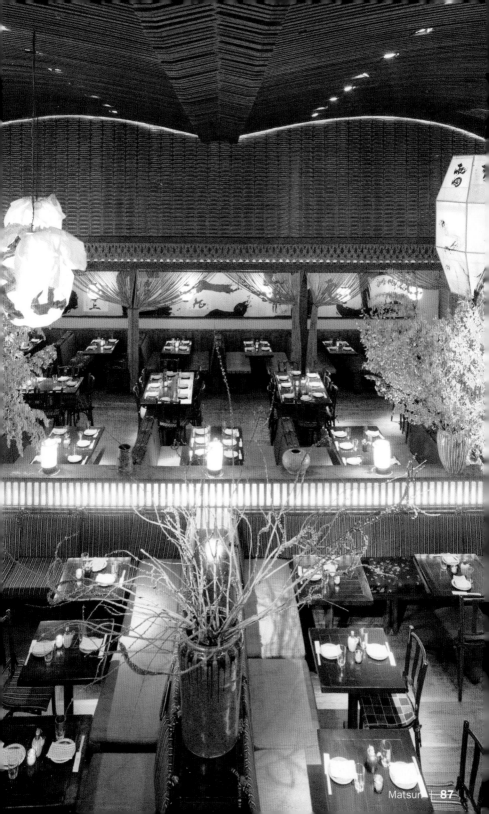

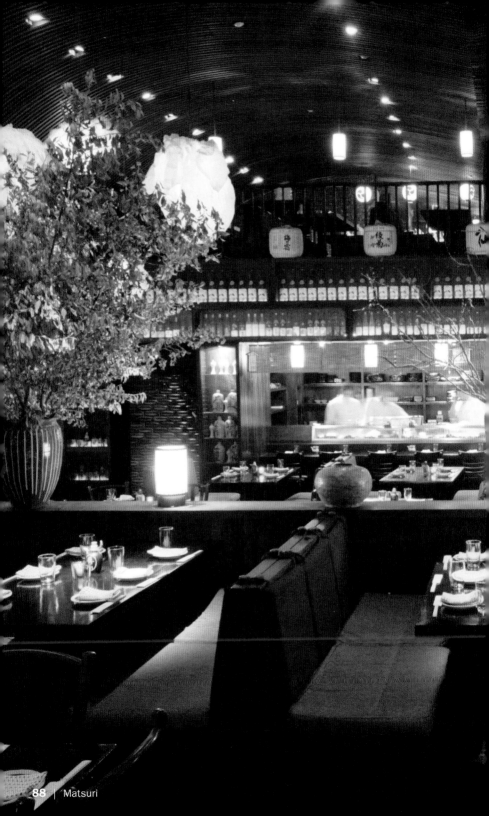

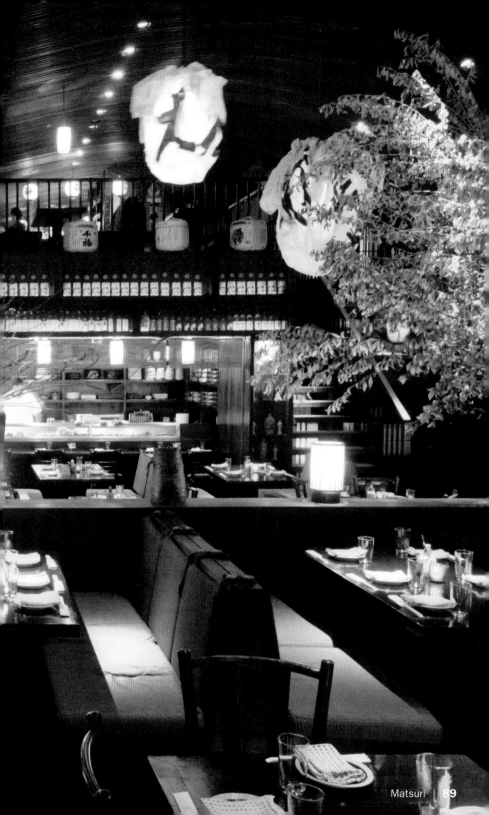

Mercer Kitchen

Design: Christian Liaigre | Chef: Christopher Beischer
Owner: Jean-Georges Vongerichten

99 Prince Street | New York, NY 10012 | SoHo
Phone: +1 212 966 5454
www.jean-georges.com
Subway: N, R, W Prince Street; B,D,F,V Broadway – Lafayette Street
Opening hours: Mon–Thu 7 am to midnight, Fri–Sat 7 am to 1 am, Sun 7 am to midnight
Average price: Lunch $ 25, dinner $ 43
Cuisine: American
Special features: The main dining room extends beneath a glass sidewalk

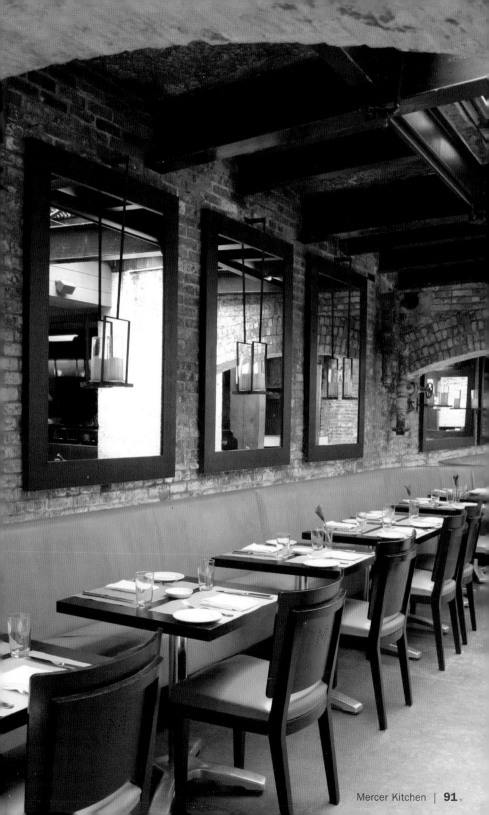

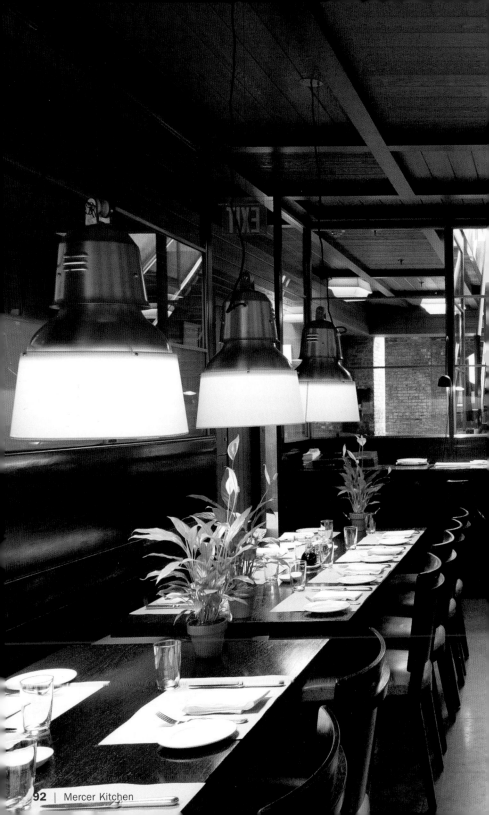

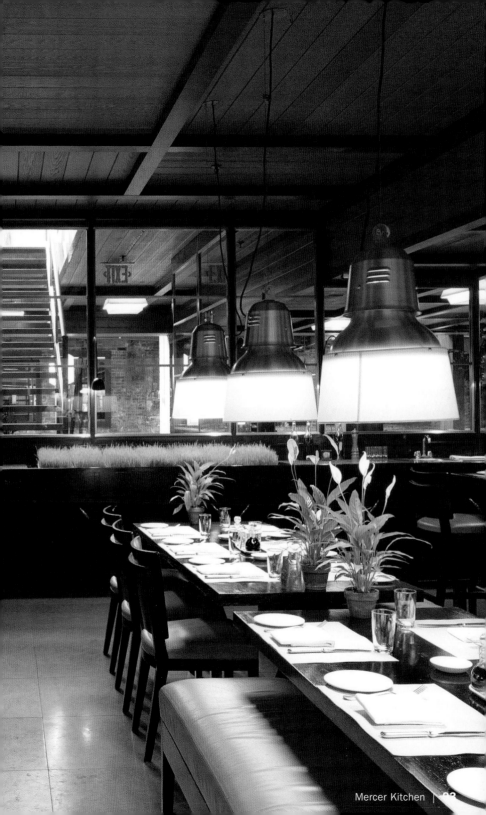

Tuna Wasabi Pizza

Thunfisch-Wasabi-Pizza

Pizza-Thon-Wasabi

Pizza atún y wasabi

Pizza tonno e wasabi

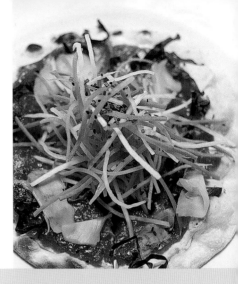

1 lb flour
200 ml warm water
1 cube baking yeast
1 tsp salt
1 tbsp honey
2 tbsp olive oil

Dissolve yeast in warm water. Work flour, salt and yeast-water mixture into a dough, work in honey and olive oil. Add more flour if the dough is too sticky. Let rise at a warm place for 1 hour.

7 oz cream cheese, 7 oz ricotta cheese
100 ml mirin
2 tbsp rice vinegar
2 tbsp white wine
3 tbsp Wasabi
2 tsp lime juice
Salt, pepper

Combine all ingredients, season and chill.

7 oz tuna, seasoned with salt, pepper and olive oil
Carrot and celery strips
Pickled ginger
Fresh seaweed

Divide the dough into 4 portions and roll into circles. Spread the cheese paste on the dough and bake at 390°F for 20 minutes. In the meantime, place the tuna inbetween cling film and flatten until very thin. Remove the pizza from the oven, arrange the tuna, vegetable strips, ginger and seaweed on top and serve immediately.

500 g Mehl
200 ml warmes Wasser
1 Päckchen Hefe
1 TL Salz
1 EL Honig
2 EL Olivenöl

Hefe in warmem Wasser auflösen. Mehl, Salz und Hefe-Wassermischung verkneten, Honig und Olivenöl unterarbeiten. Löffelweise Mehl einarbeiten, falls der Teig klebt. An einem warmen Ort 1 Stunde gehen lassen.

200 g Frischkäse, 200 g Ricotta
100 ml Mirin
2 EL Reisweinessig
2 EL Weißwein
3 EL Wasabi
2 TL Limettensaft
Salz, Pfeffer

Zutaten mischen, abschmecken und kaltstellen.

200 g Thunfisch, gewürzt mit Salz, Pfeffer und Olivenöl
Karotten- und Selleriejulienne
Eingelegter Ingwer
Frische Algen

Den Teig in 4 Portionen teilen und kreisrund ausrollen. Mit der Käsepaste bestreichen und bei 200°C 20 Minuten backen. Den Thunfisch zwischen zwei Klarsichtfolien hauchdünn klopfen. Die Pizza herausnehmen, Thunfisch, Gemüsejulienne, Ingwer und Algen darauf verteilen und sofort servieren.

500 g de farine
200 ml d'eau chaude
1 cube de levure de boulanger
1 c. à café de sel
1 c. à soupe de miel
2 c. à soupe d'huile d'olive

Dissoudre la levure dans l'eau chaude. Travailler la farine, le sel et le mélange eau-levure pour faire une pâte, travailler encore avec le miel et l'huile d'olive. Ajouter plus de farine si la pâte est trop collante. Laisser lever dans un endroit chaud pendant une heure.

200 g de fromage frais, 200 g de ricotta
100 ml de mirin
2 c. à soupe de vinaigre de riz
2 c. à soupe de vin blanc
3 c. à soupe de wasabi
2 c. à café de jus de citron vert
Sel, poivre

Mélanger tous les ingrédients, assaisonner et mettre au frais.

200 g de thon cru salé, poivré et badigeonné d'huile d'olive
Lamelles de carottes et de céleri
Gingembre mariné
Algues fraîches

Diviser la pâte en 4 portions et l'aplatir en cercles. Etaler la préparation au fromage sur la pâte et faire cuire au four à 200°C pendant 20 minutes. Pendant ce temps, mettre le thon dans du film étirable et l'aplatir pour qu'il soit très fin. Enlever la pizza du four, disposer par-dessus le thon, les lamelles de légumes, le gingembre et les algues et servir immédiatement.

500 g de harina
200 ml de agua caliente
1 cubito de levadura de horno
1 cucharadita de sal
1 cucharada de miel
2 cucharadas de aceite de oliva

Disolver la levadura en agua caliente. Mezclar la harina, la sal y el agua más levadura y amasar, luego añadir la miel y el aceite y amasar más. Añadir más harina si la masa está demasiado pegajosa. Dejar reposar en un lugar caliente durante 1 hora.

200 g de queso crema, 200 g de queso ricotta
100 ml de mirin (vino dulce de arroz)
2 cucharadas de vinagre de arroz
2 cucharadas de vino blanco
3 cucharadas de wasabi
2 cucharaditas de zumo de lima
Sal y pimienta

Combinar todos los ingredientes, aderezar y dejar resfriar.

200 g de atún aderezado con sal, pimienta y aceite de oliva
Zanahoria y apio en tiras
Jengibre en escabeche
Algas frescas

Repartir la masa entre 4 porciones y enrollar en forma circular. Rociar la pasta de queso sobre la masa y cocer en el horno a 200ºC durante 20 minutos. Mientras tanto, poner el atún entre dos hojas de película y aplastar hasta que esté muy fino. Quitar la pizza del horno, disponer el atún, las verduras en tiras, el jengibre y las algas encima y servir inmediatamente.

500 g di farina
200 ml di acqua calda
1 dado di lievito da forno
1 cucchiaino di sale
1 cucchiai di miele
2 cucchiai di olio d'oliva

Sciogliere il lievito in acqua calda. Mescolare la farina, il sale e l'acqua con il lievito e impastare. Aggiungere il miele e l'olio d'oliva e impastare di nuovo. Aggiungere altra farina se l'impasto è troppo appiccicoso. Lasciare lievitare in un luogo caldo per 1 ora.

200 g di formaggio fresco, 200 g di ricotta
100 ml di mirin
2 cucchiai di aceto di riso
2 cucchiai di vino bianco
3 cucchiai di wasabi
2 cucchiaini di succo di lime
Sale e pepe

Combinare tutti gli ingredienti, condire e lasciare raffreddare.

200 g di tonno condito con sale, pepe e olio d'oliva
Carote e sedano a filetti
Zenzero in agrodolce
Alghe fresche

Ripartire l'impasto in 4 porzioni, arrotolarle e appiattirle in forma circolare. Spargere la pasta di formaggio sull'impasto e cuocere in forno a 200°C per 20 minuti. Sistemare il tonno tra due strati di pellicola e appiattirlo fino a ridurlo a uno strato molto fine. Togliere la pizza dal forno, disporre il tonno, le striscioline vegetali, lo zenzero e le alghe in cima e servire immediatamente.

Nobu Fifty Seven

Design: David Rockwell | Chef, Owner: Nobuyuki Matsuhisa
Co-Owner: Robert De Niro

40 West 57th Street | New York, NY 10019 | Midtown
Phone: +1 212 757 3000
www.noburestaurants.com
Subway: F, N, R, Q, W 57 Street
Opening hours: Daily 6 pm to 11 pm
Average price: $ 50
Cuisine: Japanese
Special features: Shabu-Shabu & Hibachi tables

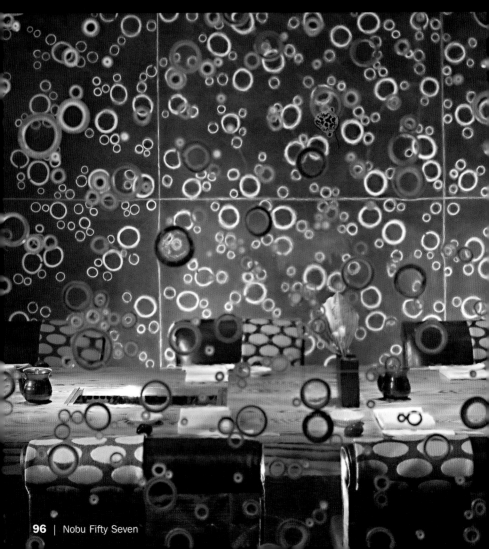

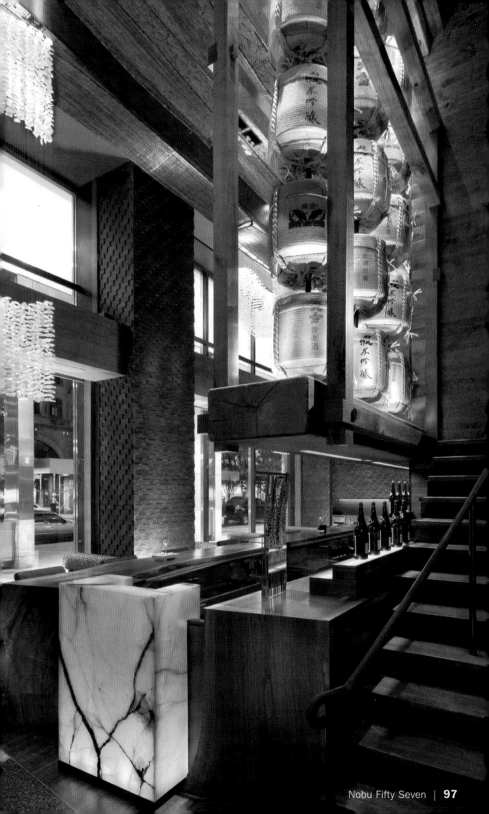

Peasant

Design: Carlos Salazar, Frank DeCarlo | Chef, Owner: Frank DeCarlo

194 Elizabeth Street | New York, NY 10012 | SoHo
Phone: +1 212 965 9511
www.peasantnyc.com
Subway: N, R Prince Street; 6 Spring Street
Opening hours: Tue–Sat 6 pm to 11 pm, Sun 6 pm to 10 pm
Average price: $ 55
Cuisine: Regional Italian
Special features: Suckling pig over wood fire rotisserie

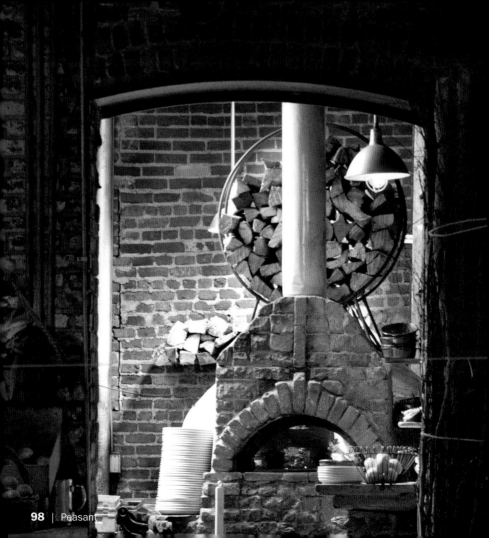

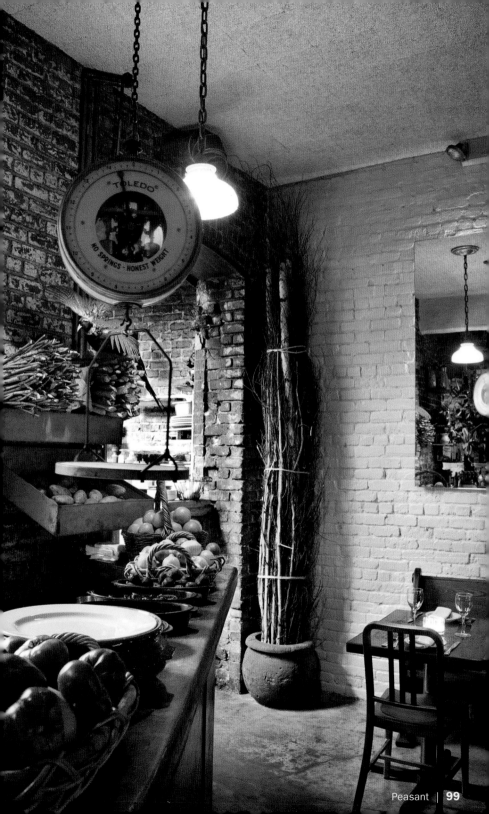

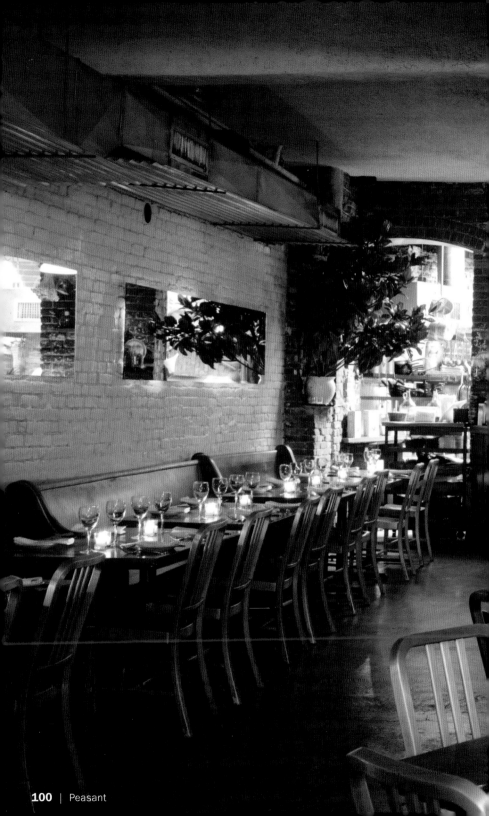

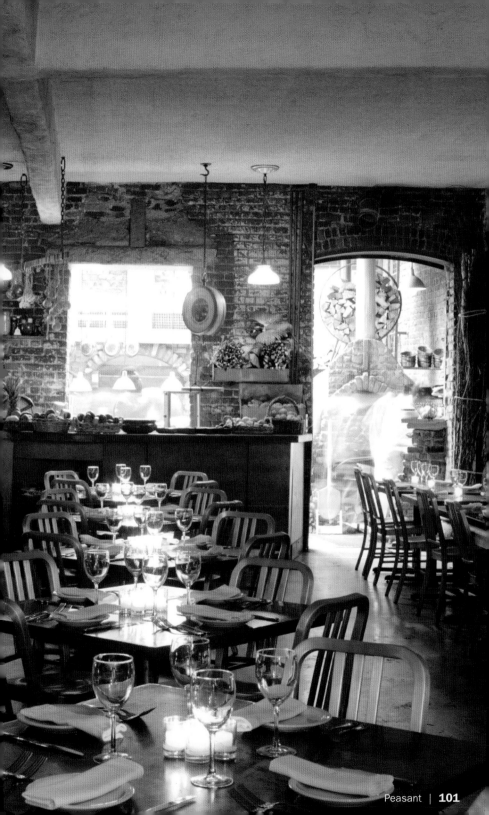

Boccocini

16 slices bacon, 1,5 x 2 in.
16 mozzarella balls
8 leaves radicchio
4 tsp olive oil
4 tsp bread crumbs
4 tips basil
Ciabatta bread

Place 2 leaves of radicchio on the bottom of 4 baking dishes, put the bacon-wrapped mozzarella balls on top and drizzle with olive oil. Place for approx. 3 minutes in a 410 °F oven. Take out, sprinkle with bread crumbs and bake for another 3 minutes. Garnish with basil tips and serve with ciabatta bread.

16 Scheiben Speck, 4 x 6 cm
16 Mozzarellabällchen
8 Blätter Radicchio
4 TL Olivenöl
4 TL Semmelbrösel
4 Spitzen Basilikum
Ciabatta

Jeweils 2 Blätter Radicchio auf den Boden von 4 Auflaufformen geben, die in Speck eingewickelten Mozzarellabällchen darauf legen und mit Olivenöl beträufeln. Für ca. 3 Minuten in einen 220 °C heißen Backofen geben. Herausnehmen, mit Semmelbröseln bestreuen und nochmals 3 Minuten backen. Mit Basilikumspitzen garnieren und mit Ciabatta servieren.

16 tranches de lard, 4 x 6 cm
16 boulettes de mozzarella
8 feuilles de salade radicchio
4 c. à café d'huile d'olive
4 c. à café de chapelure
4 têtes de basilic
Pain ciabatta

Préparer à chaque fois 2 feuilles de radicchio sur le fond de 4 moules à gratiner, déposer dessus les boulettes de mozzarella enroulées de lard, et asperger d'un peu d'huile d'olive. Passer au four préchauffé à 220 °C, environ 3 minutes. Les sortir du four et les couvrir de chapelure, puis les repasser au four pendant 3 minutes. Garnir de têtes de basilic et servir avec du ciabatta (pain italien).

16 rodajas de tocino, 4 x 6 cm
16 bolitas de mozzarella
8 hojas de radicheta
4 cucharadas de aceite de oliva
4 cucharadas de pan rallado
4 puntas de albahacas
Ciabatta

Colocar 2 hojas de radicheta sobre el piso de cada una de 4 formas para gratinar, colocar encima las bolitas de mozzarella envueltas en tocino y salpicar con aceite de oliva. Colocar por aprox. 3 minutos en un horno a 220 °C. Sacar, espolvorear con pan rallado y luego volver a hornear por 3 minutes. Adornar con puntas de albahaca y servir con ciabatta.

16 fette di speck, 4 x 6 cm
16 palline di mozzarella
8 foglie di radicchio
4 cucchiaini di olio d'oliva
4 cucchiaini di pangrattato
4 punte di basilico
Ciabatta

Mettere 2 foglie di radicchio, rispettivamente, sulla base di 4 teglie per sformati, posizionare lì sopra le palline di mozzarella avvolte nello speck e versare un filo di olio d'oliva. Mettere in un forno riscaldato a 220 °C per circa 3 minuti. Togliere dal forno, cospargere con il pangrattato e cuocere ancora per 3 minuti. Guarnire con le punte di basilico e servire con la ciabatta.

Perry St

Design: Thomas Juul-Hansen | Owner, Chef: Jean-Georges Vongerichten

176 Perry Street | New York, NY 10014 | West Village
Phone: +1 212 352 1900
www.jean-georges.com
Subway: 1, 9 Christopher Street; A, C, E, L 14 Street; F, B, D, A, C, E West 4 Street –
Washington Square
Opening hours: Mon–Sun noon to 3 pm, 6 pm to midnight
Average price: Lunch $ 30, dinner $ 70
Cuisine: Modern American
Special features: Sunset facing Hudson River

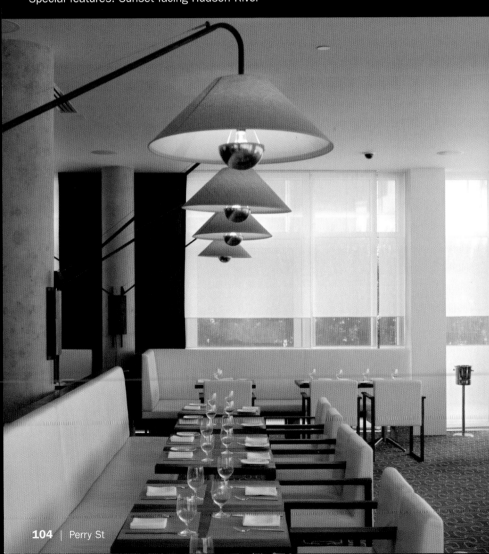

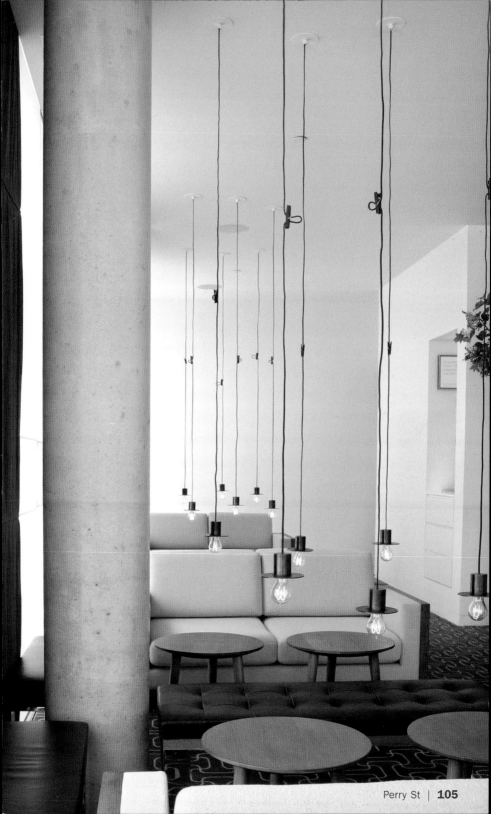

Summer Vegetable Salad
with Warm Dill Broth

Sommergemüsesalat mit warmer Dillbrühe

Salade d'été avec consommé d'aneth

Ensalada de verduras de verano con consomé caliente de eneldo

Insalata di verdure estiva con zuppa di aneto calda

2 l vegetable stock
1 carrot, peeled, in thin slices
1 stick celery, peeled, in thin slices
1 kohlrabi, peeled, in thin slices
1 onion, peeled, in thin slices
1 chilli, halved
1 stick lemongrass, halved
4 twigs thyme
4 twigs parsley
2 bay leaves

Heat the vegetable stock, add the vegetables and simmer for 20 minutes, take off the stove and add chilli, lemongrass and herbs. Let set for 20 minutes, then drain and reserve the broth. Remove chilli, lemongrass and herbs.

1 avocado, diced
4 radishes, in wedges
3 tbsp lemon juice
3 tbsp dill, chopped
Salt, pepper
Croutons
Lime wedges

Fold avocado and radishes under the cooked vegetables and divide on plates. Season the broth with lemon juice and dill and season with salt and pepper, if necessary. Place croutons and lime wedges on the vegetables, serve broth separately.

2 l Gemüsebrühe
1 Karotte, geschält, in dünnen Scheiben
1 Stange Staudensellerie, geschält, in dünnen Scheiben
1 Kohlrabi, geschält, in dünnen Scheiben
1 Zwiebel, geschält, in dünnen Scheiben
1 Chilischote, halbiert
1 Stange Zitronengras, halbiert
4 Zweige Thymian
4 Zweige Petersilie
2 Lorbeerblätter

Die Gemüsebrühe erhitzen, das Gemüse hineingeben und 20 Minuten kochen, vom Herd nehmen und Chili, Zitronengras und Kräuter hinzufügen. 20 Minuten ziehen lassen, dann abseihen und die Brühe aufbewahren. Chili, Kräuter und Zitronengras entfernen.

1 Avocado, gewürfelt
4 Radieschen, in Spalten
3 EL Zitronensaft
3 EL Dill, gehackt
Salz, Pfeffer
Croutons
Limettenachtel

Avocado und Radieschen unter das gekochte Gemüse heben und auf Teller verteilen. Die Brühe mit Zitronensaft und Dill abschmecken und evtl. mit Salz und Pfeffer würzen. Croutons und Limettenachtel auf das Gemüse geben, die Brühe separat servieren.

2 l de bouillon de légume
1 carotte, pelée, en fines tranches
1 tige de céleri en branches, épluchée et
coupée en fines tranches
1 chou-rave, épluché, en minces tranches
1 oignon épluché et en fines tranches
1 piments, coupés par moitié
1 pied de lemon grass, coupé de moitié
4 branches de thym
4 branches de persil
2 feuilles de laurier

Faire chauffer le bouillon de légume, verser les
légumes et laisser cuire 20 minutes, retirer du
feu et ajouter les piments, le lemon grass et
les herbes. Laisser reposer 20 minutes, passer
au chinois et conserver le bouillon. Jeter les
piments, herbes et lemon grass.

Couper 1 avocat en dés
4 radis en lamelles
3 c. à soupe de jus de citron
3 c. à soupe d'aneth hachée
Sel, poivre
Croûtons
Limette coupée en huit

Mélanger aux légumes cuits l'avocat et les radis
et répartir dans les assiettes. Assaisonner le
bouillon de jus de citron et d'aneth, et éventuel-
lement saler et poivrer. Déposer les croûtons et
la limette coupée en huit sur les légumes, servir
le bouillon séparément.

2 litros de consomé de verduras
1 zanahoria, cortada en rodajas finas
1 un asta de apio en rama, cortada en
rodajas finas
1 colinabo, cortado en rodajas finas
1 cebolla, cortada en rodajas finas
1 vaina de pimentón, cortada por la mitad
1 un tallo de hierbaluisa, cortado por la mitad
4 ramas de tomillo
4 ramas de perejil
2 hojas de laurel

Calentar el consomé de verduras, introducir
en el mismo las verduras y cocer por 20 minu-
tos, sacar del fuego y añadir el pimentón, la
hierbaluisa y las hierbas. Dejar descansar por
20 minutos, luego colar y guardar el caldo.
Sacar el pimentón, las hierbas y la hierbaluisa.

1 aguacate cortado en dados
4 rabanitos en trozos
3 cucharadas de jugo de limón
3 cucharadas de eneldo picado
Sal, pimienta
Dados de pan
Un octavo de lima

Rellenar con aguacate y rabanitos las verduras
cocinadas y distribuirlas sobre platos. Sazonar
el consomé con jugo de limón y eneldo y even-
tualmente aderezar con sal y pimienta. Colocar
los daditos de pan y los octavos de lima sobre
la verdura, servir por separado el consomé.

2 litri di brodo vegetale
1 carota sbucciata e tagliata a dischi sottili
1 gambo di cespo di sedano sbucciato e taglia-
to a dischi sottili
1 cavolo rapa sbucciato e tagliato a dischi sottili
1 cipolla sbucciata e tagliata a dischi sottili
1 baccello di peperone diviso a metà
1 gambo di erba limone diviso a metà
4 rami di timo
4 rami di prezzemolo
2 foglie di alloro

Riscaldare il brodo vegetale, versarci la verdura
e far cuocere 20 minuti, togliere dal fuoco e
aggiungere il peperone, l'erba limone e le erbe.
Far riposare 20 minuti, quindi filtrare e conser-
vare il brodo. Togliere il peperone, le erbe e
l'erba limone.

1 avocado tagliato a dadini
4 ravanelli tagliati a fettine
3 cucchiai di succo di limone
3 cucchiai di aneto tritato
Sale, pepe
Crostini
Ottavi di limetta

Amalgamare l'avocado e i ravanelli con la ver-
dura cotta e distribuirli su un piatto. Insaporire
il brodo con il succo di limone e l'aneto ed,
eventualmente, aggiungere sale e pepe. Mettere
i crostini e gli ottavi di limette sulla verdura,
servire il brodo a parte.

Spice Market

Design: Jacques Garcia | **Executive Chef:** James Reinholt
Owners: Jean-Georges Vongerichten, Phil Suarez

403 West 13th Street | New York, NY 10014 | Meatpacking District
Phone: +1 212 675 2322
www.jean-georges.com
Subway: A, C, E, L 14 Street
Opening hours: Sun–Thu noon to midnight, Fri–Sat noon to 1 am
Average price: Lunch $ 37, dinner $ 51
Cuisine: South, Eastern Asian
Special features: Late-night dining

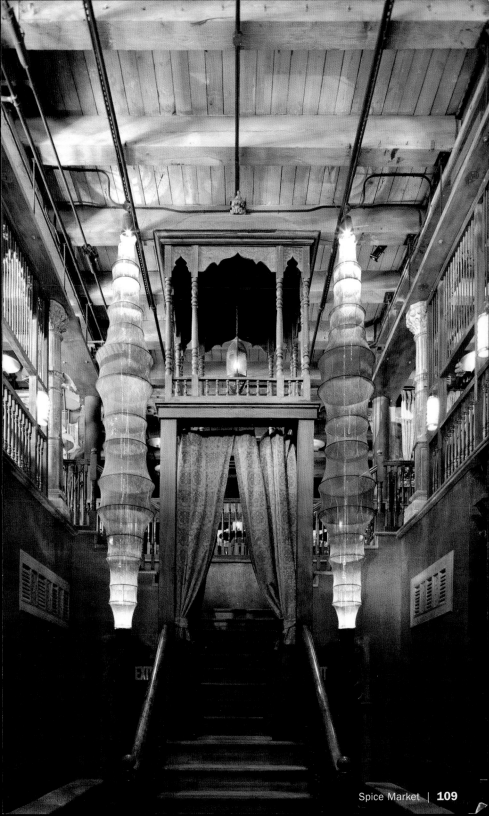

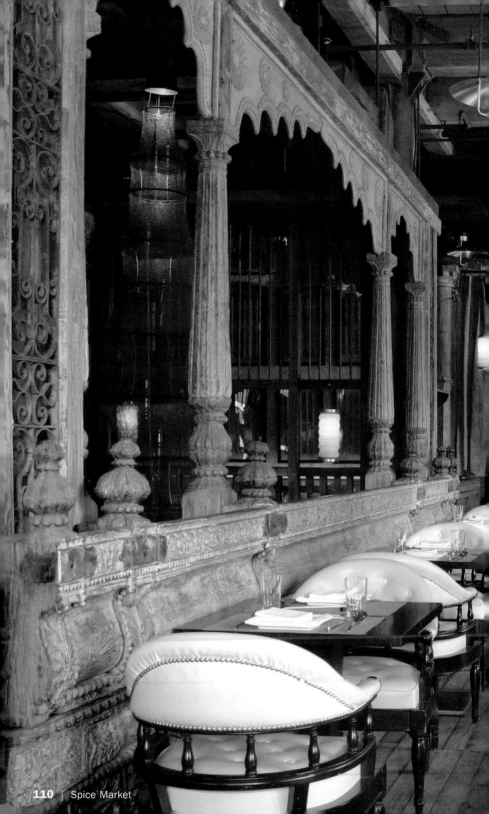

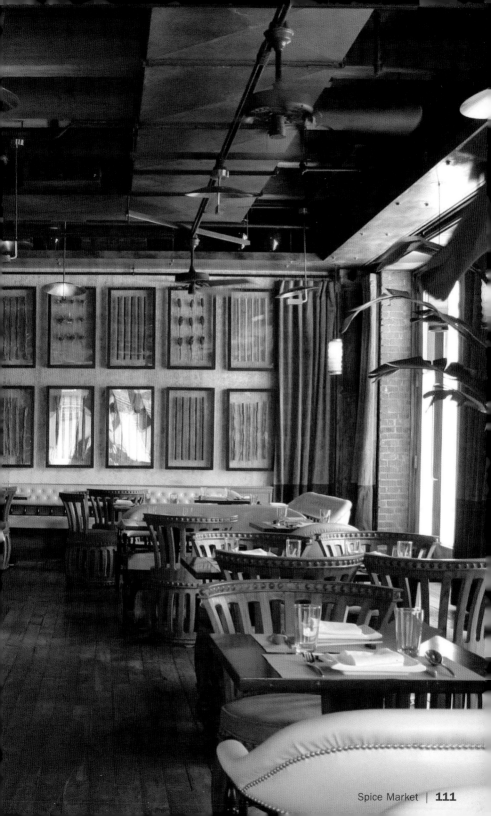

Chicken Satay

Hähnchen Satay

Poulet Satay

Pollo Satay

Polletto Satay

4 chicken breasts, in strips

Marinade:
4 tbsp shallots, diced
3 tbsp peanuts, roasted and chopped
1 tbsp cilantro seeds, roasted and ground
1 tsp cumin, roasted and ground
125 ml coconut milk
1 tsp curcuma powder
1 tbsp evaporated milk
1 tbsp palm sugar
2 tbsp Nam Pla (fish sauce)
1 tbsp Whiskey
1 pinch salt

Peanut sauce:
1 tbsp sugar
1 tbsp red curry paste
1 tsp vegetable oil
180 ml coconut milk
7 oz peanuts, roasted
1 tbsp soy sauce
Puree all ingredients into a creamy paste.

Place all ingredients for the marinade in a blender and mix into a smooth paste. Stick the chicken strips on wooden sticks and place in the marinade and refrigerate at least overnight. Remove from the marinade and fry in a very hot pan with little oil or on a char-coal grill for 2 minutes on each side. Serve with peanut sauce.

4 Hähnchenbrüste, in Streifen

Marinade:
4 EL Schalotten, gehackt
3 EL Erdnüsse, geröstet und gehackt
1 EL Koriandersamen, geröstet und gemahlen
1 TL Kreuzkümmel, geröstet und gemahlen
125 ml Kokosnussmilch
1 TL Kurkumapulver
1 EL Kondensmilch
1 EL Palmzucker
2 EL Nam Pla (Fischsauce)
1 EL Whiskey
1 Prise Salz

Erdnusssauce:
1 EL Zucker
1 EL Rote Currypaste
1 TL Pflanzenöl
180 ml Kokosnussmilch
200 g Erdnüsse, geröstet
1 EL Sojasauce
Alle Zutaten zu einer cremigen Paste pürieren.

Alle Zutaten für die Marinade in einen Mixer geben und zu einer glatten Paste verarbeiten. Die Hühnerbruststreifen auf Holzspieße stecken und in der Marinade einlegen und mindestens über Nacht im Kühlschrank marinieren lassen. Aus der Marinade nehmen und in einer sehr heißen Pfanne mit wenig Fett oder auf einem Holzkohlegrill von jeder Seite 2 Minuten grillen. Mit Erdnusssauce servieren.

4 poitrines de poulet en lamelles

Marinade :
4 c. à soupe d'échalotes hachées
3 c. à soupe de cacahuètes grillées et
hachées
1 c. à soupe de grains de coriandre, grillés et
moulus
1 c. à café de cumin, grillé et moulu
125 ml de lait de coco
1 c. à café de curcuma en poudre
1 c. à soupe de lait condensé
1 c. à soupe de sucre de palme
2 c. à soupe de Nam Pla (sauce de poisson)
1 c. à soupe de Whisky
1 prise de sel

Sauce de cacahuète :
1 c. à soupe de sucre
1 c. à soupe de pâte de curry rouge
1 c. à café d'huile végétale
180 ml de lait de coco
200 g de cacahuètes grillées
1 c. à soupe de sauce de soja
Passer tous les ingrédients au mixeur pour
former une pâte crémeuse.

Passer au mixeur tous les ingrédients de la mari-
nade pour obtenir une sauce bien lisse. Mettre
les lamelles de poitrine de poulet sur des bro-
chettes en bois et les déposer dans la marinade
et les laisser au moins toute la nuit mariner au
réfrigérateur. Sortir les brochettes de la marinade
et les faire frire dans une poêle très chaude avec
peu de graisse, ou griller sur un barbecue au
charbon de bois, pendant 2 minutes sur chaque
côté. Servir avec la sauce de cacahuètes.

4 pechugas de pollo, en lonjas

Escabeche:
4 cucharadas de chalote, picado
3 cucharadas de cacahuete, tostado y picado
1 cucharada de semillas de cilantro, tostadas
y picadas
1 cucharadita de comino, tostado y picado
125 ml de leche de coco
1 cucharadita de polvo de cúrcuma
1 cucharada de leche condensada
1 cucharada de azúcar de palmera
2 cucharadas de Nam Pla (salsa de pescado)
1 cucharada de Whiskey
1 pizca de sal

Salsa de cacahuete:
1 cucharada de azúcar
1 cucharada de pasta colorada de curry
1 cucharadita de aceite vegetal
180 ml de leche de coco
200 g de cacahuetes tostados
1 cucharada de salsa de soja
Moler todos los ingredientes hasta que se
vuelvan una pasta cremosa.

Introducir todos los ingredientes para el esca-
beche en la batidora y elaborar hasta que se
forme una pasta uniforme. Colocar las tiras de
pechugas de pollo ensartadas en brochetes de
madera en el escabeche y dejar marinar por lo
menos por una noche en la heladera. Sacar del
escabeche y colocar en una sartén muy caliente
con algo de grasa o sobre una parrilla calentada
con carbón vegetal y asar por dos minutos de
cada lado. Servir con los cacahuetes.

4 petti di pollo tagliati a strisce

Marinata:
4 cucchiai di scalogno tritati
3 cucchiai di arachidi tostate e tritate
1 cucchiaio di semi di coriandolo tostati e
macinati
1 cucchiaino di cumino tostato e macinato
125 ml di latte di noce di cocco
1 cucchiaino di curcuma in polvere
1 cucchiaio di latte condensato
1 cucchiaio di zucchero di palma
2 cucchiai di Nam Pla (salsa di pesce)
1 cucchiaio di whisky
1 presa di sale

Salsa di arachidi:
1 cucchiaio di zucchero
1 cucchiaio di pasta di Curry rossa
1 cucchiaino di olio vegetale
180 ml di latte di noce di cocco
200 g di arachidi tostate
1 cucchiaio di salsa di soia
Passare tutti gli ingredienti fino a ottenere una
pasta cremosa.

Versare tutti gli ingredienti per la marinata in un
mixer e lavorare fino a ottenere un impasto unifor-
me. Infilare le strisce di petti di pollo su spiedini
di legno e metterli nella marinata; farli marinare
in frigorifero per almeno una notte. Toglierli dalla
marinata e rosolarli in una padella molto calda,
leggermente unta, o grigliarli da ciascun lato per
2 minuti su un grill a carbone di legna. Servire con
la salsa di arachidi.

Stand

Design: Studio Gaia | Owner: Jonathan Morr

24 East 12th Street | New York, NY 10003 | Greenwich Village
Phone: +1 212 488 5900
www.standburger.com
Subway: N, Q, R, W, 4, 5, 6, L Union Square
Opening hours: Daily noon to midnight
Average price: $ 10
Cuisine: American burgers
Special features: Alcoholic milkshakes

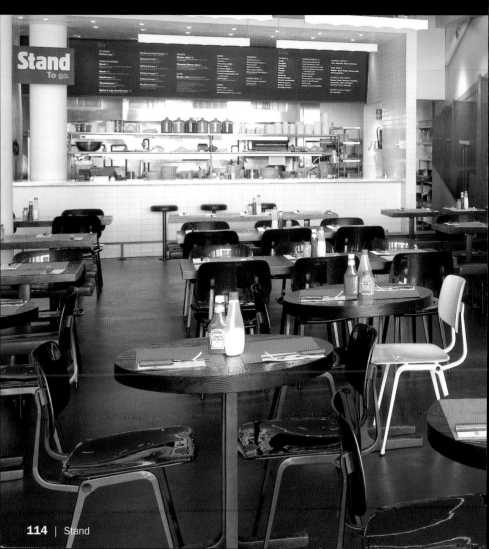

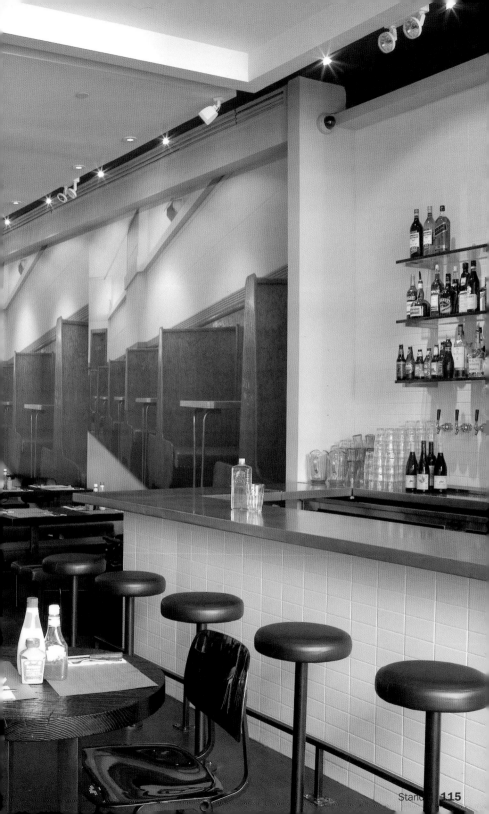

Telepan

Design: Modern Eclectic | Chef, Owner: Bill Telepan

72 West 69th Street | New York, NY 10023 | Upper West Side
Phone: +1 212 580 4300
www.telepan-ny.com
Subway: B, C 72 Street
Opening hours: Wed–Fri 11:30 am to 2:30 pm, Sat–Sun 11 am to 2:30 pm (brunch),
Mon–Thu 5 pm to 11 pm, Fri–Sat 5 pm to 11:30 pm, Sun 5 pm to 10:30 pm
Average price: $ 50
Cuisine: Modern American
Special features: Four fireplaces, semi-private dining room

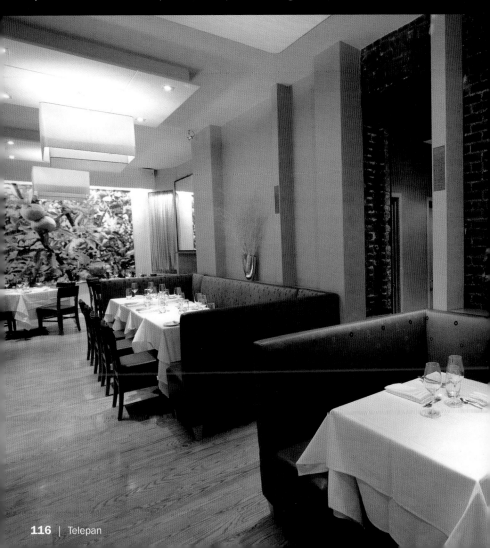

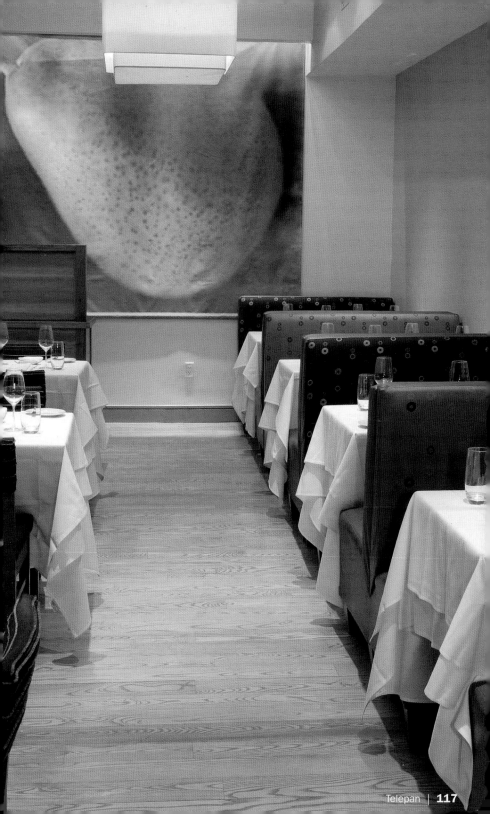

The Spotted Pig

Design: Ken Friedman | Chef: April Bloomfield
Owners: Ken Friedman, April Bloomfield

314 West 11th Street | New York, NY 10014 | West Village
Phone: +1 212 620 0393
www.thespottedpig.com
Subway: A, C, E 14 Street; 1, 9 Sheridan Square
Opening hours: Daily noon to 3 pm, 5:30 pm to 2 am; Bar menu 3 pm to 5:30 pm,
Weekend's brunch 11 am to 3 pm
Average price: $ 40
Cuisine: Modern European

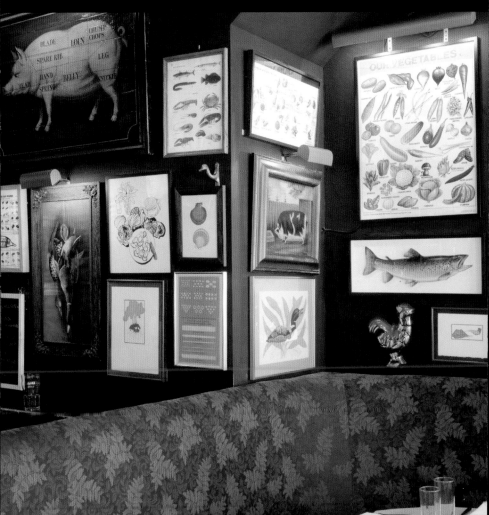

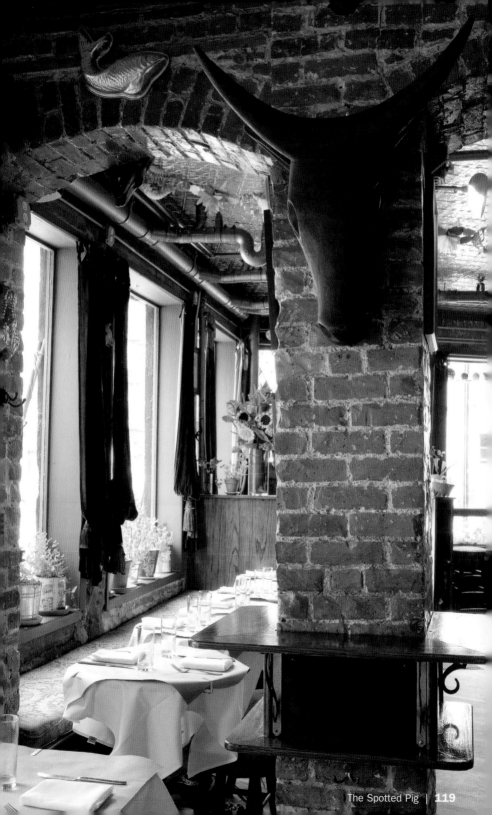

The Stanton Social

Design: AvroKO | Chef: Chris Santos
Owners: Peter Kane, Chris Santos, Richard Wolf

99 Stanton Street | New York, NY 10002 | Lower East Side
Phone: +1 212 995 0099
www.thestantonsocial.com
Subway: F, V Second Avenue
Opening hours: Sun–Tue 5 pm to 2 am, Wed–Sat 5 pm to 3 am,
Sat–Sun 11:30 am (brunch)
Average price: $ 30
Cuisine: International fusion
Special features: Late-night dining

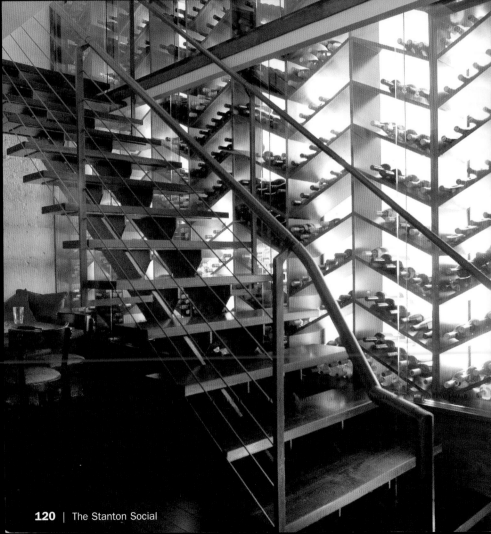

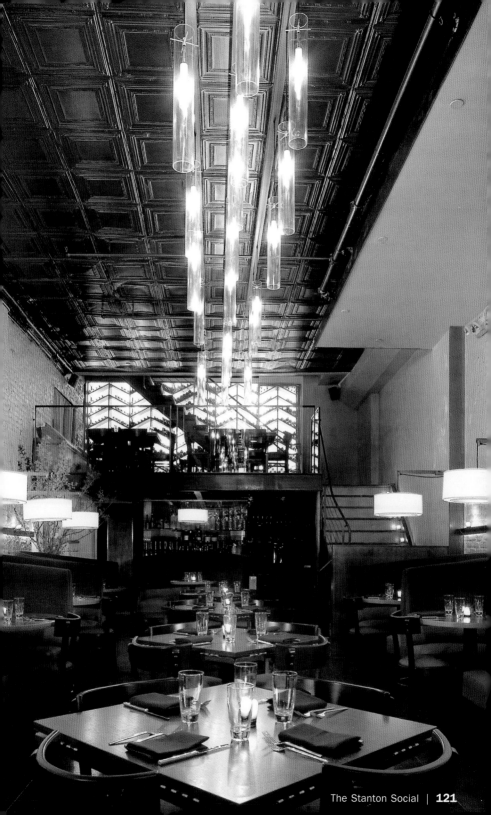

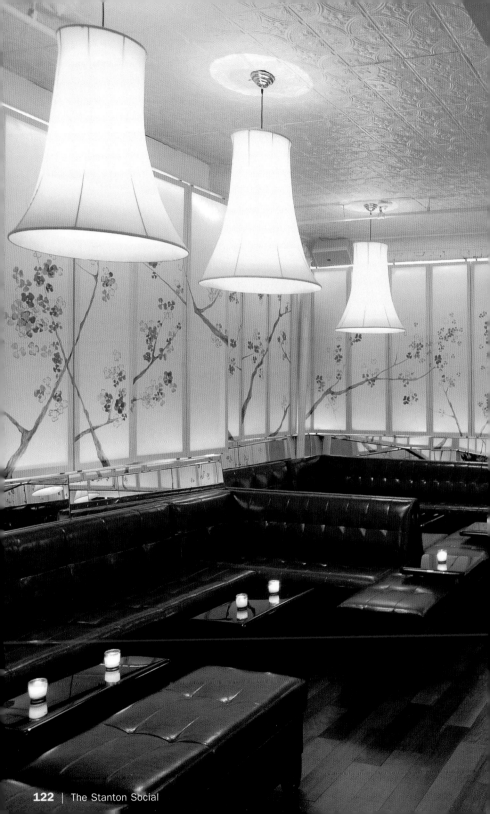

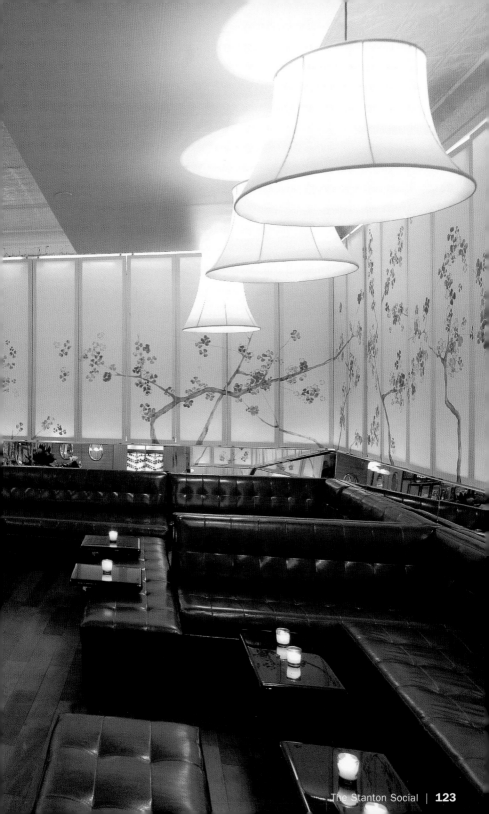

Una Pizza Napoletana

Design, Chef, Owner: Anthony Mangieri

349 East 12th Street | New York, NY 10003 | East Village
Phone: +1 212 477 9950
www.unapizza.com
Subway: L First Avenue
Opening hours: Thu–Sun 5 pm until sold out of fresh dough
Average price: $ 30
Cuisine: Italian
Special features: Top-notch ingredients, dough mixed by hand

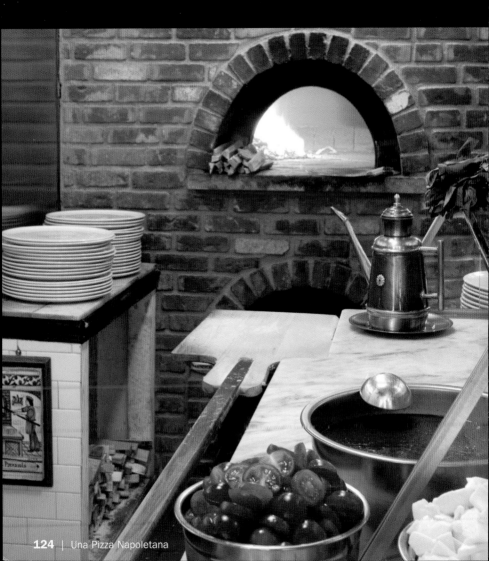

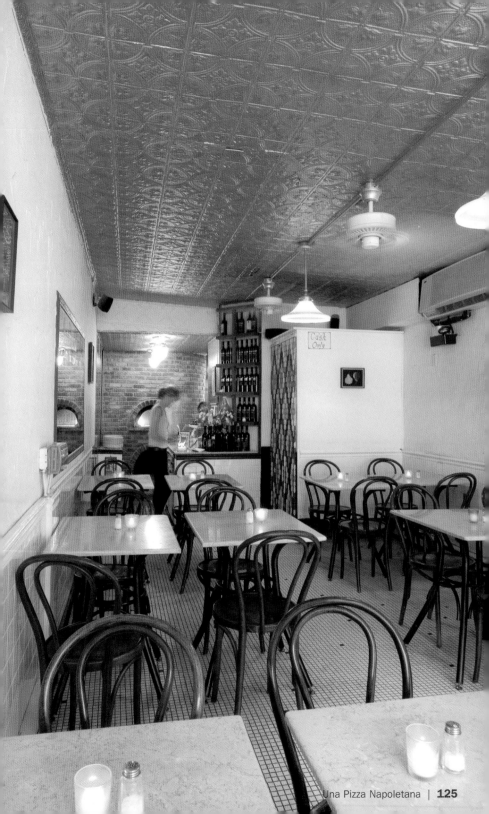

Wallsé

Design: Constantin Wickenberg architects
Chef, Owner: Kurt Gutenbrunner

344 West 11th Street | New York, NY 10014 | West Village
Phone: +1 212 352 2300
www.wallse.com
Subway: 1, 9 Christopher Street
Opening hours: Mon–Sun 5:30 pm to 11:30 pm, Sat–Sun 11 am to 3:30 pm (brunch)
Average price: $ 70
Cuisine: Austrian
Special features: Large Austrian wine collection, paintings by Julian Schnabel

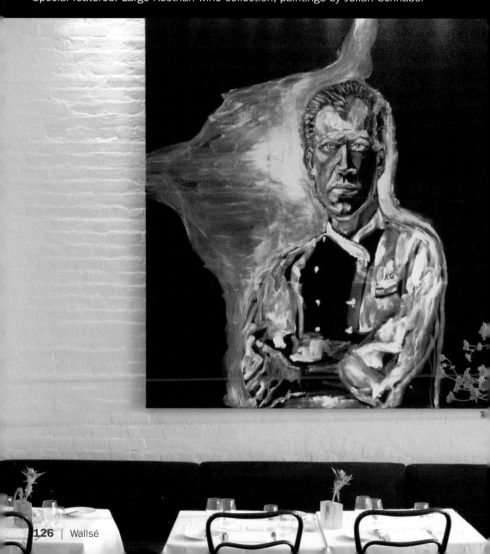

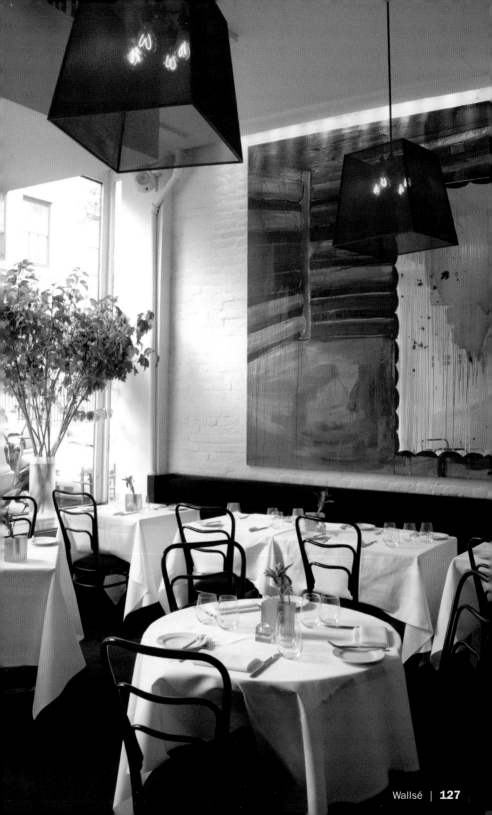

Halibut

with Cucumber and Dillchanterelles

Heilbutt mit Gurken und Dillpfifferlingen

Turbot sur concombres et girolles à l'aneth

Rodaballo con pepinos y cantarelas de eneldo

Ippoglosso con cetrioli e galletti d'aneto

4 halibut fillets, 6 oz each
2 onions cut in rings
250 ml olive oil
1 bunch dill
2 cucumbers
3 tbsp vegetable oil
1 lb chanterelles, cleaned and halved
1 tbsp shallots, diced
1 tbsp thyme, chopped
Salt, pepper
Lemon juice
4 large twigs dill

Sauté onions in little vegetable oil until tender, mash and set aside. Puree oil and dill into a smooth liquid. Chill. Core one of the cucumbers, and dice with the skin, reserve the seeds. Peel the second cucumber and puree with the reserved seeds. Strain through a cloth and set the cucumber liquid aside. Sauté the chanterelles in oil, add the diced shallots and the thyme and season with salt and pepper. Keep warm. Put diced cucumbers with 8 tbsp cucumber liquid, 8 tbsp mashed onions, salt and pepper in a pot and heat. Season the halibut, sear for 2 minutes on both sides and let rest for 4 minutes in a pre-heated oven. Add 4 tbsp dill oil to the cucumbers and season with lemon juice. Divide the cucumbers onto 4 plates, place the halibut fillet on top, garnish with a twig of dill and sprinkle with chanterelles.

4 Heilbuttfilets, à 180 g
2 Zwiebeln, in Ringe geschnitten
250 ml Olivenöl
1 Bund Dill
2 Gurken
3 EL Pflanzenöl
500 g Pfifferlinge, geputzt und halbiert
1 EL Schalotte, gewürfelt
1 EL Thymian, gehackt
Salz, Pfeffer
Zitronensaft
4 große Zweige Dill

Zwiebeln in etwas Pflanzenöl weich garen, mit einem Pürierstab pürieren und beiseite stellen. Öl und Dill zu einer glatten Flüssigkeit pürieren. Kalt stellen. Eine der Gurken entkernen und mit der Schale würfeln, die Kerne aufbewahren. Die zweite Gurke schälen und mit den zurückbehaltenen Kernen pürieren. Durch ein Stofftuch abseihen und das Gurkenwasser aufbewahren. Die Pfifferlinge in Öl anbraten, die Schalottenwürfel und den Thymian zugeben und mit Salz und Pfeffer würzen. Warm halten. Gurkenwürfel mit 8 EL Gurkenwasser, 8 EL Zwiebelpüree, Salz und Pfeffer in einen Topf geben und erwärmen. Den Heilbutt würzen, von beiden Seiten 2 Minuten anbraten und 4 Minuten in einem vorgeheizten Ofen ruhen lassen. 4 EL Dillöl zu dem Gurkengemüse geben und mit Zitronensaft abschmecken. Das Gurkengemüse auf 4 tiefe Teller verteilen, das Heilbuttfilet darauf setzen, jeweils einen Zweig Dill auf den Fisch geben und mit den Pfifferlingen bestreuen.

4 filets de turbot de 180 g
2 oignons, coupés en rondelles
250 ml d'huile d'olive
1 bouquet d'aneth
2 concombres
3 c. à soupe d'huile végétale
500 g de girolles, nettoyées et coupées en deux
1 c. à soupe d'échalote, en dés
1 c. à soupe de thym haché
Sel, poivre
Jus de citron
4 grosse branche d'aneth

Faire revenir les oignons dans un peu d'huile végétale, les passer au mixeur à purée et les mettre de côté. Passer au mixeur l'huile et l'aneth en fine purée. Ranger au frais. Epépiner l'un des concombres et le couper en dés avec la peau, conserver les pépins. Eplucher le second concombre et le passer au mixeur avec les pépins conservés de l'autre. Presser dans un torchon et conserver le jus de concombre. Faire revenir les girolles dans l'huile, ajouter l'échalote et le thym, et saler et poivrer. Tenir au chaud. Mettre dans un pot les dés de concombre avec 8 c. à soupe de jus de concombre, 8 c. à soupe de purée d'oignons, saler, poivrer, et chauffer. Faire frire le turbot 2 minutes des deux côtés et laisser reposer 4 minutes dans un four préchauffé. Ajouter au concombre 4 c. à soupe du mélange huile aneth et assaisonner au jus de citron. Répartir le concombre sur 4 assiettes creuses, déposer dessus le filet de turbot, avec pour chaque une petite branche d'aneth sur le poisson, et ajouter quelques girolles.

4 filetes de rodaballo de 180 g
2 cebollas cortadas en anillos
250 ml de aceite de oliva
1 manojo de eneldo
2 pepinos
3 cucharadas de aceite vegetal
500 g de cantarela, limpia y cortada por la mitad
1 cucharada de chalote, cortada en dados
1 cucharada de tomillo picado
Sal, pimienta
Jugo de limón
4 ramas grandes de eneldo

Poner a punto las cebollas con algo de aceite vegetal, hacer puré con una varilla de hacer puré y poner a un costado. Hacer puré con aceite y eneldo hasta que tenga la consistencia de un líquido uniforme. Poner en frío. Sacar las semillas de un pepino y cortarlo en dados con la piel, guardar las semillas. Pelar el otro pepino y hacerlo puré junto con las semillas guardadas. Filtrar con un paño y guardar el agua del pepino. Fritar las cantarelas en aceite, agregar los dados de chalote y el tomillo y sazonar con sal y pimienta. Mantener caliente. Poner los dados del pepino con 8 cucharadas de agua de pepino, 8 cucharadas de puré de cebolla, sal y pimienta en una olla y calentar. Sazonar el rodaballo, asar por 2 minutos en cada lado y dejar descansar por 4 minutos en un horno precalentado. Agregar 4 cucharadas de aceite de eneldo a la verdura de pepinos y sazonar con jugo de limón. Distribuir la verdura de pepinos en 4 platos hondos, colocar encima el filete de rodaballo, colocar sobre cada pescado una rama de eneldo y espolvorear con las cantarelas.

4 filetti di ippoglosso da 180 g
2 cipolle tagliate ad anelli
250 ml di olio d'oliva
1 mazzo di aneto
2 cetrioli
3 cucchiai di olio vegetale
500 g di galletti puliti e tagliati a metà
1 cucchiaio di scalogno tagliato a dadini
1 cucchiaio di timo tritato
Sale, pepe
Succo di limone
4 rami di aneto grandi

Stufare leggermente la cipolla in un po' di olio vegetale, passare la cipolla con un frullatore a immersione e metterla da parte. Passare l'olio e l'aneto fino a ottenere un liquido uniforme. Mettere in fresco. Rimuovere la parte del nucleo di uno dei cetrioli e farlo a cubetti con la buccia, conservare la parte del nucleo. Sbucciare il secondo cetriolo e passarlo insieme con la parte del nucleo conservata precedentemente. Filtrare con una tela di stoffa e conservare l'acqua dei cetrioli. Rosolare in olio i galletti, aggiungere i dadini di scalogno e il timo, e insaporire con sale e pepe. Tenerli in caldo. Versare in una pentola il cetriolo tagliato a dadini con 8 cucchiai di acqua dei cetrioli, 8 cucchiai di purea di cipolle, sale e pepe e riscaldare. Insaporire l'ippoglosso, far rosolare da entrambi i lati per 2 minuti e far riposare in forno preriscaldato per 4 minuti. Versare 4 cucchiai di olio all'aneto nella crema cetrioli e insaporire con il succo di limone. Distribuire la crema di cetrioli in 4 piatti fondi, posizionare lì sopra il filetto di ippoglosso, mettere un ramo di aneto su ciascun pesce e cospargere con i galletti.

wd~50

Design: Dewey Dufresne, Louis Mueller, Asfour Guzy (Architects)
Chef, Owner: Wylie Dufresne

50 Clinton Street | New York, NY 10002 | Lower East Side
Phone: +1 212 477 2900
www.wd-50.com
Subway: F Delancey Street; J, M, Z Essex Street
Opening hours: Mon–Sat 6 pm to 11:30 pm, Sun 6 pm to 10:30 pm
Average price: $ 67
Cuisine: Modern American
Special features: Private dining room in wine cellar

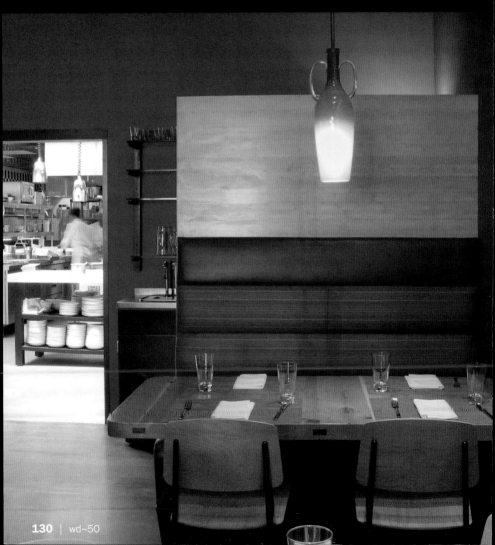

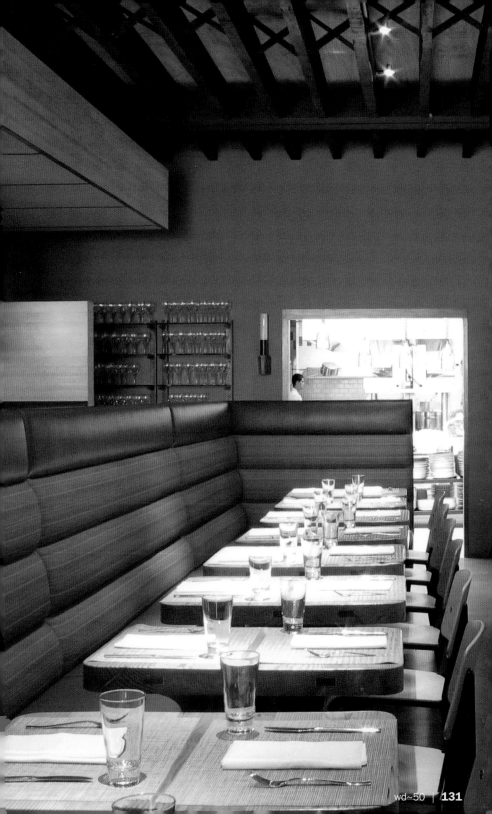

Caramelized Apple

with Miso Ice Cream
and preserved Plum Puree

Karamellisierter Apfel mit Miso-Eis und
Pflaumenmus

Pomme caramélisée avec glace de miso
et mousse de prune

Manzana caramelizada con hielo Miso
y mousse de ciruela

Mele caramellate con gelato al miso
e marmellata di prugne

10 apples, peeled, cored and diced,
4 oz sugar, 1 vanilla bean, 375 ml white wine

Reduce all ingredients at medium heat to a syr-
upy liquid, remove the vanilla beam and mash
into a puree.

1 lb apple puree, 100 ml water, 100 ml white
wine, 0.07 oz gellan (jelly), 0.02 oz maltodextro

Heat apple puree; in the meantime combine
water, white wine, gellan and maltodextro. Heat
the mixture until it begins to thicken, stirring
constantly. As soon as the mixture becomes
liquidly again, stir in the apple puree and pour
into a square dish. Chill for one hour.

500 ml milk, 190 ml cream, 2 ½ oz glucose,
½ oz trimoline, 1 ½ oz milk powder, 0.08 oz
stabilizer, 2 eggs, 3 oz white miso (soy pow-
der), cookie crumbs, plum puree

Heat milk, cream, glucose and trimoline. Stir in
milk powder and stabilizer and bring to a boil.
Take off the stove and stir in eggs and miso.
Pour through a strainer, chill and freeze in an ice
cream machine.

Cut the apple jelly into cubes, sprinkle with sugar
and caramelize with a Bunsen burner. Arrange 3
cubes of apple jelly with 1 scoop of ice cream on
a plate, sprinkle with cookie crumbs and garnish
with some plum puree (convenience product).

10 Äpfel, geschält, entkernt und gewürfelt, 120 g
Zucker, 1 Vanillestange, 375 ml Weißwein

Alle Zutaten bei mittlerer Hitze sirupartig einko-
chen, die Vanillestange entfernen und zu einem
Püree verarbeiten.

400 g Apfelpüree, 100 ml Wasser, 100 ml
Weißwein, 2,3 g Gellan (Geliermittel), 0,5 g
Maltodextrin

Apfelpüree erwarmen, in der Zwischenzeit
Wasser, Weißwein, Gellan und Maltodextrin
mischen. Die Mischung erhitzen bis sie andickt,
dabei kräftig rühren. Sobald die Mischung wie-
der flüssig wird, das Apfelpüree einrühren und
in ein rechteckiges Gefäß geben. Eine Stunde
kalt stellen.

500 ml Milch, 190 ml Sahne, 75 g Glukose, 16 g
Trimoline, 45 g Milchpulver, 2,5 g Stabilisator,
2 Eier, 90 g weißer Miso (Sojapulver), Keksbrösel,
Pflaumenmus

Milch, Sahne, Glukose und Trimoline erwärmen.
Milchpulver und Stabilisator einrühren und zum
Kochen bringen. Vom Herd nehmen und die Eier
und den Miso einrühren. Durch ein Sieb gießen,
abkühlen lassen und in einer Eismaschine
gefrieren.

Das Apfelgelee in Würfel schneiden, mit Zucker
bestreuen und mit einem Bunsenbrenner
karamellisieren. Jeweils 3 Apfelgeleewürfel
mit 1 Kugel Eis auf einem Teller anrichten,
mit Keksbröseln bestreuen und mit etwas
Pflaumenmus (Fertigprodukt) garnieren.

10 pommes, épluchées, épépinées et coupées en cubes, 120 g de sucre, 1 gousse de vanille, 375 ml de vin blanc

Cuire tous les ingrédients à feu moyen pour obtenir une sorte de sirop, retirer la gousse de vanille et réduire en purée.

400 g de purée de pomme, 100 ml d'eau, 100 ml de vin blanc, 2,3 g de gélatine, 0,5 g de dextrine-maltose

Réchauffer la purée de pomme, entre-temps mélanger l'eau, le vin blanc, la gélatine et la dextrine-maltose. Chauffer la préparation jusqu'à ce qu'elle s'épaississe, bien remuer pendant cette opération. Dès que le mélange redevient liquide, verser la purée de pomme en continuant à remuer, puis mettre le tout dans un récipient rectangulaire. Mettre au froid pendant une heure.

500 ml de lait, 190 ml de crème liquide, 75 g de glucose, 16 g de trimoline, 45 g de lait en poudre, 2,5 g de stabilisateur, 2 œufs, 90 g de miso blanc (poudre de soja), miettes de biscuits, compote de prunes.

Chauffer le lait, la crème liquide, le glucose et la trimoline. Verser en remuant la poudre de lait et le stabilisateur et porter à ébullition. Retirer du feu et ajouter les œufs et le miso en remuant. Passer au chinois, laisser refroidir et glacer dans une machine à glacer.

Couper en dés la gelée de pomme, saupoudrer de sucre, puis caraméliser à l'aide d'un brûleur à main. Draper par assiette 3 dés de gelée de pomme et 1 boule de glace, en saupoudrant des miettes de biscuits et garnir d'un peu de compote de prune (produit du commerce).

10 manzanas peladas, sin semillas y cortadas en dados, 120 g de azúcar, 1 varilla de vainilla, 375 ml de vino blanco

Todos los ingredientes se tienen que cocer a fuego lento hasta que tengan la consistencia de jarabe, sacar la varilla de vainilla y convertir todo en un puré.

400 g de puré de manzanas, 100 ml de agua, 100 ml de vino blanco, 2,3 g Gellan (sustancia formadora de gelatina), 0,5 g maltosa-dextrina

Calentar el puré de manzanas, en el tiempo intermedio mezclar agua, vino blanco, Gellan y maltosa-dextrina. Calentar la mezcla hasta que se vuelva espesa, agitar en el proceso con energía. Apenas la mezcla se vuelve nuevamente fluida, mezclar el puré de manzanas y verter en el recipiente rectangular. Colocar una hora en frío.

500 ml de leche, 190 ml de nata, 75 g de glucosa, 16 g sémola, 45 g leche en polvo, 2,5 g estabilizador, 2 huevos, 90 g Miso blanco (polvo de soja), galleta rallada, mousse de ciruela

Calentar la leche, la nata, la glucosa y la sémola. Introducir agitando la leche en polvo y el estabilizador y llevar a la ebullición. Sacar del fuego e introducir agitando los huevos y el Miso. Pasar a través de un colador, dejar enfriar y enfriar en una máquina de hielo.

Cortar la gelatina de manzanas en daditos, espolvorear con azúcar y caramelizar con un quemador de Bunsen. Colocar en cada plato 3 dados de gelatina de manzanas con 1 bola de hielo, espolvorear con la galleta rallada y adornar con un poco de mousse de ciruela (producto terminado).

10 mele sbucciate, private del nucleo e tagliate a dadini, 120 g di zucchero, 1 bastoncino di vaniglia, 375 ml di vino bianco

Cuocere a media temperatura e far addensare tutti gli ingredienti a mo' di sciroppo, rimuovere il bastoncino di vaniglia e lavorarli fino a ottenere una purea.

400 g di purea di mele, 100 ml di acqua, 100 ml di vino bianco, 2,3 g di gellan (gelificante), 0,5 g di maltodestrina

Riscaldare la purea di mele, nel frattempo mescolare l'acqua, il vino bianco, il gellan e la maltodestrina. Riscaldare la miscela finché non si rapprende, mescolandola con forza. Quando la miscela diventa di nuovo liquida, aggiungere, mescolando, la purea di mele, e versare in un contenitore rettangolare. Tenere al fresco per un'ora.

500 ml di latte, 190 ml di panna, 75 g di glucosio, 16 g di trimoline, 45 g di latte in polvere, 2,5 g di stabilizzatore, 2 uova, 90 g di miso bianco (soia in polvere), biscotti sbriciolati, marmellata di prugne

Riscaldare il latte, la panna, il glucosio e la trimoline. Aggiungere, mescolando, il latte in polvere e lo stabilizzatore, e portare a ebollizione. Togliere dal fuoco e aggiungere, mescolando, le uova e il miso. Passare in un colino, far raffreddare e congelare in una macchina per il ghiaccio.

Tagliare a cubetti la gelatina di mele, cospargerla di zucchero e caramellarla con un becco Bunsen. In un piatto disporre 1 pallina di ghiaccio ogni 3 cubetti di gelatina di mele, cospargere con i biscotti sbriciolati e guarnire con un po' di marmellata di prugne (prodotto confezionato).

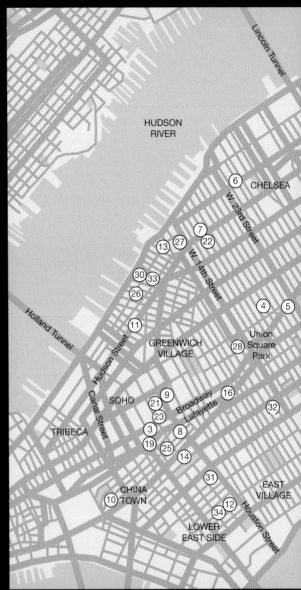

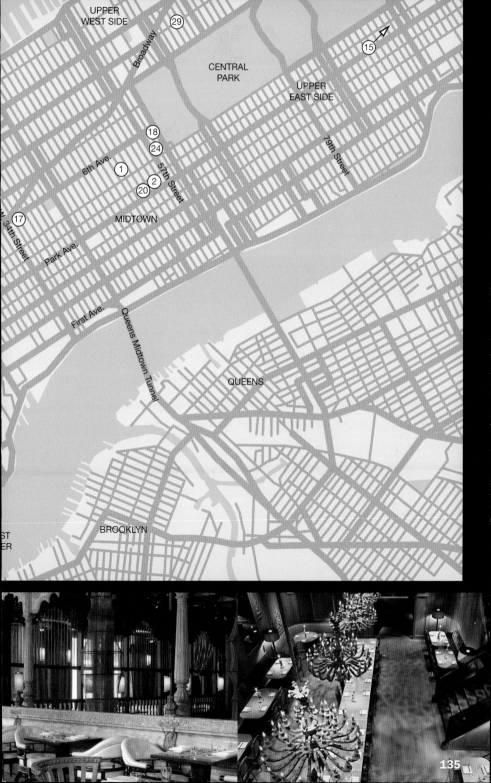

Cool Restaurants

COOL SHOPS

COOL SPOTS

Size: 14,6 x 22,5 cm
5 ¾ x 8 ¾ in.
136 pp, Flexicover
c. 130 color photographs
Text in English, German, French,
Spanish, Italian or (*) Dutch

teNeues